Sydney Goodsir Smith

Embro Toun '40

THE DRAWINGS OF
Sydney Goodsir Smith
POET

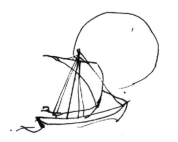

Collected by Ian Begg

Edited by Joy Hendry

Published on behalf of the New Auk Society by
Chapman Publishing, 4 Broughton Place, Edinburgh in collaboration with
Tuckwell Press, The Mill House, Phantassie, East Linton, EH40 3DG.
A catalogue record for this volume is available from the British Library,
ISBN 1 86232 035 7

The publisher acknowledges the financial assistance of the
Scottish Arts Council and the W L Lorimer Memorial Trust Fund.

Designed by Charles Miller Graphics, Edinburgh.

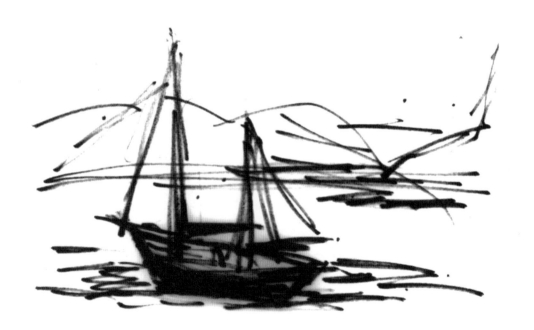

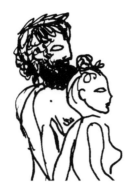

Contents

Acknowledgements

Hazel Goodsir Smith

Isobel Nicolson

Anna Macleod

Robert McIntyre

Kitty Pal

Robin and Priscilla Lorimer

Willie Prosser

The New Auk Society

The National Library of Scotland

Gerry Stewart

Joy Hendry

Ruth Fisken

Chalmers Davidson

Notebooks photographed for reproduction
by Still Print, Edinburgh.

Dedicated to all Jock Tamson's bairns

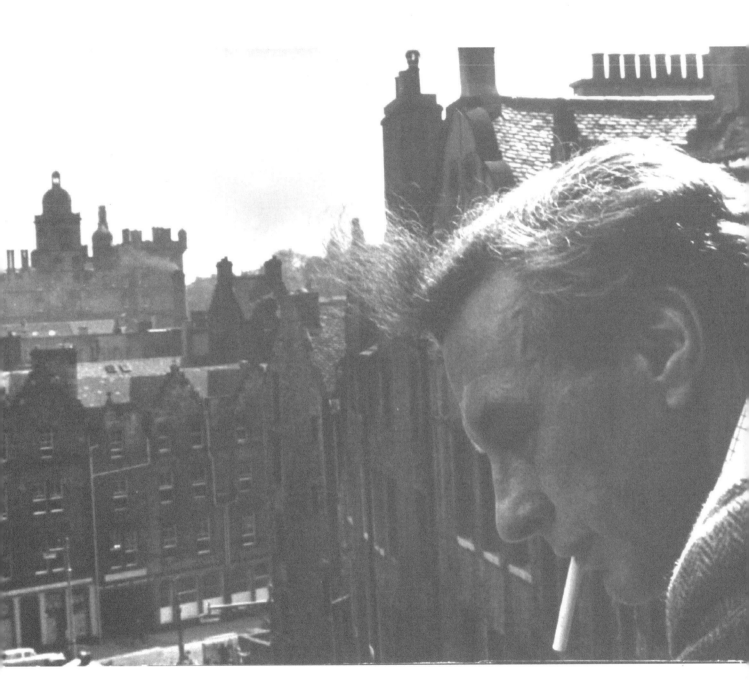

THE DARK DAYS ARE BY

O the winter's bin lang, my luve, my luve,
Frae this northern lan the sun's bin awa,
We've aa got weary o waitin, my luve,
 for the days of thaw.

O the nichts've bin lang, my luve, my luve,
The darkness o Scotlan for aa these years,
But yon's the dawn liftin up, my luve,
 An the end o tears.

The trees 've bin bare, my luve, my luve,
The fields 've lain black neth the lowrin sky,
But the green is bursting an spreadin, my luve,
 For the dark days are by.

O the glory's uprising, my luve, my luve,
Ye can hear Scotlan's hert pulsin fierce wi the Spring
They'll not silence this music again, my luve,
 Howeer they ding!

For we've waited ower lang, my luve, my luve,
As they wha'd thwart an constrain us'll see,
Aye, we've each the richt o a man, my luve,
 Tae gang free!

Sydney Goodsir Smith

Cordelia Oliver

For a few years in the early 1960s Sydney Goodsir Smith and I were colleagues. Sydney's wonderfully readable, amusingly opinionated but mostly very perceptive reviews of art exhibitions in Edinburgh galleries appeared regularly in *The Scotsman* while I was cutting my critical and journalistic teeth in the pages of *The Glasgow Herald*. The two newspapers were rivals then as now – and those were the days when editors would demand that even an art critic's copy be supplied by early evening on the day of the exhibition's press review, giving little opportunity to spend a leisurely evening polishing the prose style.

The rivalry, then, ought by rights to have extended to Sydney and myself. Nothing, however, could have been further from the truth. We would meet once or twice a month or more, usually in Edinburgh since the Glasgow art scene was temporarily in the doldrums. Our meetings were, for me, immensely enjoyable and indeed educational in matters beyond the visual arts in which I was more or less as well informed as Sydney. But, as I found to my delight, the art critic of *The Scotsman* was splendid company, not just amusing in himself but also singularly knowledgeable. I remember thinking that to be with him was a bit like going back in time, to the eighteenth century, perhaps.

From whatever exhibition we had seen that morning, at the Royal Scottish Academy, or one of the National Galleries, at Aitken Dott's or the little new '57 Gallery 'up a close' in George Street, I would be persuaded, not that

much persuasion was needed, to keep Sydney company to Milne's Bar, traditional meeting place and talking shop for Edinburgh poets. It was in fact an unassuming, not to say tatty, basement where Sydney Goodsir Smith was utterly and happily at home among his peers while I, as a rule, kept silence and listened.

It was always with reluctance that I would make up my departure to catch the Glasgow train, using the journey to write my review in time to meet the deadline. Since I had left the convivial coterie in full flood, and showing no signs of breaking up, I never ceased to wonder when Sydney's review appeared, readable and informative as always, sometimes provocative but seldom without reason, in the next morning's *Scotsman*. He was such a wordsmith as I could not help envying, even in the potentially mundane field of daily reviewing. In the end *The Scotsman* sacked him because he refused to tailor his opinions to suit the 'Establishment'.

As a painter by training I was continually impressed by Sydney's intuitive understanding of genuinely interesting work and by his critical acumen. He was also quick to spot the meretricious and showy for its own sake, not least in the work of some 'weel kent' names. So I found it easy to forgive him when, as occasionally happened, one of his judgements proved perverse. I did not know then that his dearest wish on leaving school had been to study art. And it was only when I saw an exhibition of his watercolours a few years later that I recognised his talent as being well above that of the ordinary amateur painter. That exhibition was an eye-opener, revealing a sensitive eye-and-hand response to landscape both in structure and in atmospheric quality. I have since regretted the fact that I didn't buy one although, as with so many covetable things seen on gallery walls over the years, I suppose that I couldn't find the money.

The one-man show in question was held in an enterprising but sadly short-lived gallery, The Crestine, adjacent to the Assembly Rooms in George Street. It was run by the three Pompa sisters, Edinburgh Italians whose enthusiasm for art and artists was nothing if not endearing. It was there, in the cubbyhole of an office under the stairs (for nothing, business least of all, was allowed to detract from the wall space for hanging paintings) that one might find oneself accepting hospitality – endless cups of tea in fact – along with Sydney and, on

one memorable occasion, Anne Redpath, another Crestine devotee. I can picture him now, talking endlessly and wheezing with laughter, the asthmatic's inhaler brought frequently and matter-of-factly into play.

I am ashamed to say that it is only now, all these years after his death, that I am beginning to comprehend the range and quality of Sydney Goodsir Smith's gift for visual expression – his wide-ranging gift with words is known to everyone. The drawings, not least some of the tiniest sketches, which are illustrated in this book would be reason enough for celebration even if their creator were otherwise unknown. Even at a time when fashion in painting, and indeed in the graphic arts also, demands a scale of eight or ten feet, not inches, there is no gainsaying the vitality of these little drawings.

Only an addict blessed with a keen satirical eye and a practised hand could have made these potent marks on paper, sparse, immediate and, at best, remarkably eloquent. To capture such impressions on paper at high speed is no easy matter, inviting failure as often as success simply because there is no time for second thoughts. But Sydney's sharp eye and obedient fingers let him down less often than anyone has a right to expect. See, for example, his continuing response to the little northern harbours, vital evocations in line and wash, all sharp accents of hulls and masts amid the linear activity of piled-up cloud formations. He was, I think, at his best with the little boats, piers and the sparkle of the water, often enough encapsulated in a few vibrant brush marks and black ink.

The watercolours I remember from that Crestine Gallery exhibition also succeeded in capturing the essence of such scenes, in quiet, telling colours. Sydney's painterly response to landscape might now be thought over-respectful, perhaps, when many contemporary painters seem to feel the need to dominate their subject matter, sometimes bringing alien influences to bear on what the eye sees. It was in the other areas of his graphic work, in his ability to pin down impressions of his fellow humans, that Sydney Goodsir Smith allowed his natural gift for satire full play. Immediacy is of the essence in these sketches, sharply satirical capturings of activity, of character, of incidents experienced, often, on European sojourns. At best, a handful of swift, telling lines is enough to set the scene, and what is more, to convey the observer's relish – see the pinning down of the self-conscious cavortings

of the Austrian male in his lederhosen and clumping boots. But there are other swift sketches – the Rialto Bridge is one such – where, however economically stated in swift pen lines and blotches, the message is very different; satire now replaced by a genuine response to the formation and the magical ambience of the Venetian scene. Did he paint Venice, I wonder?

But satire never was far away, whether in the repeated encapsulations of fore-gatherings which were nothing if not Bacchanalian (Bacchus himself puts in an appearance from time to time) or in the more economical sketches which bring Thurber to mind, both in style and subject matter, so much so, indeed, that coincidence seems unlikely.

Other drawings, more elaborate in conception, even when obviously unfinished, suggest that here was, indeed, a decorative illustrator manqué, in the mood of such 1940s luminaries as Leslie Hurry and Oliver Messel. And wasn't it Messel who, if my memory is to be trusted, was responsible for the elaborate design of the ballroom in Edinburgh's Caledonian Hotel. Sydney must surely have known him.

A wider serendipity is also evident: Sydney Goodsir Smith's interest in, and knowledge of, the visual arts of the twentieth century was extensive, and here and there among his sketches one finds echoes of everyone from Modigliani to Aubrey Beardsley. For example there's more than a suggestion of Van Gogh in one perspectively distorted sketch of Rose Street, Edinburgh, at night with that other poets' pub, the Abbotsford, in the foreground. In his strongly atmospheric sketch of the Scott Monument seen through a screen of foliage – the emotional content is unmistakable. Enjoyment of life's pleasures, sensual and emotional alike, shine through much of Sydney's graphic work just as his other positive attributes, like humour, whether affectionate or satirical, give life to the marks on the page. Indeed, it was only on the rare occasions when he aimed at academic structuring, as in the few portrait heads that I have seen among his drawings, that his lack of training let him down. But, as things were, didn't he have the best of both worlds?

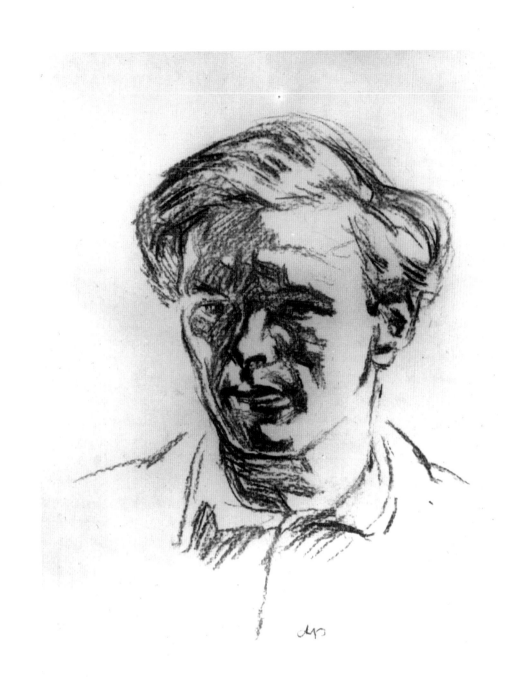

Sydney

Ian Begg

Life was, and still is, better for having known Sydney Goodsir Smith. He was a poet extraordinary in his range and in his passion for living. Sydney, born 1915 in Auckland, New Zealand, died in 1975 – too young! So many have missed the magic of this wonderful man, as Scottish as anyone I have ever met. Lively octagenarians like Sydney's great friends Sorley MacLean and Norman MacCaig, now sadly both dead, have so enriched our lives, and we can imagine what Sydney would also have contributed given another twenty years. Yet many will still remember his croaky, infectious laugh, unmistakable across the crowded bar of the Abbotsford or somewhere in a theatre audience. Many will know his poetry – almost all of it written

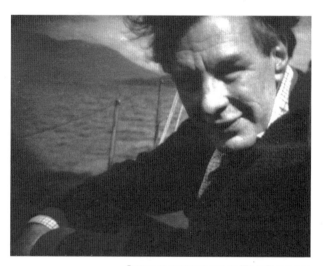

SYDNEY ON THE BOAT THE RODNEY

in Scots, combining both a texture of medieval works and the pessimism and realism of the present time, despite his rich innate humour.

People have watercolours by Sydney. Exhibition openings were convivial occasions with the walls lined with bright, vivacious watercolours of coastal scenes in Orkney, mountains like Blaven on Skye, or the Plockton Regatta. I can recall two watercolours of the same scene – the Crags across the harbour at Plockton. In one, on a wild cloudy day, the Crags rise dramatically – real mountains; whereas in the other, a calm summer Sunday, Sydney captures the still, flatness of the light, the majesty gone and everything quiet. The

range of Sydney's watercolour painting may not have been huge but its perception, wonderful light and atmosphere was remarkable.

It was in Plockton, at the home of Torquil and Isobel Nicolson and in Buachan's in Harbour Street, or visiting Sorley, that Sydney found some of his happiest times.

"Is yon Macloin the bibulic pot that bodes in Plookietoun, deid apposhite the hauspotible All Munch of Tauriquhyill Mucklestent, the electrical pumper?"

"Nane utther!"

"The saige an phoolisimper Macloon?"

"Of crumps!"

"Ye mean the ensonerator of theprimest trooth of the twattieth sanitury

– in the flash?"

"Umdumpitamply!"

"Whit a grogantic bran is ther, my contrarimen! Intlack! Mund!"

"Whatt primm trothe wazzat, man?"

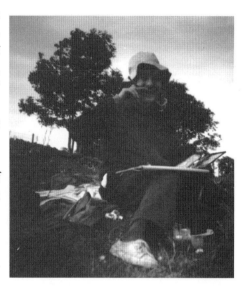

SYDNEY WORKING

Carotid Cornucopius, Caput Fowr, page 101-2

The boats, the hills, the church and other buildings in the wild, ever-changing climate of the North West were never far away in time from that intense other-place of Sydney's, his native city in Edinburgh. He loved the roads and wynds, the back streets and the people.

It wasn't just a town, it was the tradition, culture, the speech of the crowd in the pub and many significant buildings in their special setting that was Edinburgh. The long poem 'Kynd Kittock's Land', originally produced on television with black and white still photographs by Alan Daiches, gives a vivid picture of the Old Town of Edinburgh: "an auld rortie city –/ Wretched," but he saw that "Times aye cheynge and this auld runt/ Will flouer again".

(Sydney Goodsir Smith, *Collected Poems*, page 215) And so it has, for old Edinburgh is dramatically changed in the last fifteen years, but not without new problems of traffic and tourism.

In Denis Peploe's fine essay, Sydney Goodsir Smith, Painter, a tribute to Sydney in the book For Sydney Goodsir Smith, published by M. Macdonald 1975, he tells the following story:

"One recalls among many notable painting holidays in particular a trip from Edinburgh to Plockton, accompanied by the French painter Michonze. In an atmosphere of almost feverish creativity, each painter vied with the other to fill every minute with productive effort, whether it was a half-hour stop in Glencoe or the fleeting chance to paint the multi-coloured sails of a Loch Carron regatta; and then there was the evening in Murdo's bar which extended to the early hours of the morning under the benign and civilised

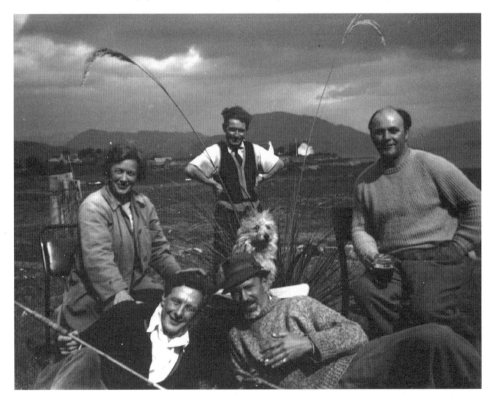

GROUP AT PLOCKTON HOTEL GARDEN

18

authority of the Ross-shire Constabulary when innumerable drawings were made of any customers who came within range, and Michonze, impatient of the restricting scale of his sketch-book, covered one whole wall with a mural depicting prominent figures of the village in a landscape setting.

It was a carefree life and frequently hilarious. One morning at breakfast, Michonze collapsed on the floor purple-faced in a paroxysm of laughter and was revived with some difficulty. A noble death it would have been, as Sydney said, "worthy of Sir Thomas Urquhart himself".

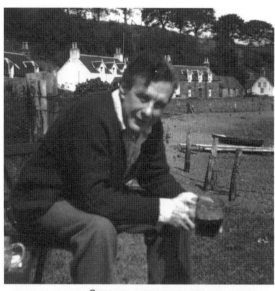

SYDNEY WITH PINT, HOTEL GARDEN.

I had the good fortune to meet Michonze in his studio flat in the rue de Seine, Paris, in the last year of his life. He was then an old man but he recalled wonderful times in Edinburgh, less so in Plockton because he didn't like the sea – he said he couldn't paint it! Picking up Denis's story, one can imagine what it might have been like in Edinburgh. Michonze had been a close friend of Salvador Dali before he became a famous man. The studio in Paris features on a film made about Henry Miller.

Sydney had an acute sense of continuity in time, and of historic connections. His character hero was the Scottish patriot William Wallace and he was probably proudest of all when his play *The Wallace* was first performed in the Assembly Hall on the Mound during the 1960 Edinburgh International Festival. There exists a lovely snapshot of Sydney on the Mound, the twin towers of the Assembly Hall behind and the great banner bearing "The Wallace" tied to the iron railings. That was possibly the first time such a banner was used to announce a play at the Assembly Hall.

Again, the discovery that one of the pieces published in *The Merry Muses of*

Caledonia edited by James Barke and Sydney Goodsir Smith (Macdonald Publishers, Edinburgh), had much earlier origins in a French poem greatly pleased Sydney. I cannot reproduce his pencil writing of that short French poem under the Burns' version in my own copy of *The Merry Muses* (it was originally Robert Hurd's) because it was stolen from my car a few years ago, but it is worth reproducing these lines:

Supper Is Na Ready (Collected by Robert Burns)

Roseberry to his lady says,
"My hinny and my succour,
"O shall we do the thing you ken,
"Or shall we take our supper?"
Wi' modest face, sae fu' o' grace,
Replied the bonny lady;
"My noble lord do as you please,
"But supper is na ready."

French version "Anon. XVI siecle"

Un frais mary dit a sa Damoiselle;
Souperons nous, ou ferons le deduit?
Faisons lequel qu'il vous plaira, dit-elle,
Mais le souper n'est pas encore cuit.

Sydney was impressed too by the generous trust and spirit shown by the Lord Rosebery of his day when the book was being compiled. Lord Rosebery left his own rare and valuable copy of the original Merry Muses with the porter at the New Club – the old New Club – for Sydney to collect. He loaned it just like that. There is an amusing drawing of club members on this page.

Sydney's father, Sir Sydney Smith, was probably able to trace his origins to London but he was a medical pioneer, and indeed father of forensic pathology and famous Dean of the Faculty of Medicine at Edinburgh University. His mother was Scots, a Goodsir, and also from a medical family. They spent much time abroad. It is not surprising that Sydney intended to be

a doctor, but the study of anatomy or morbid pathology at Edinburgh University proved more than his sensitive spirit and fertile imagination could tolerate. On confiding these problems to his father, and confessing his humanitarian reasons for wanting to study medicine in the first place, his father commented: "Another bloody sentimentalist. There are too many of them in medicine already. Go and get yourself a good liberal education." Which Sydney did, at Oxford, studying history.

He married his first wife, Marian, a doctor, when still quite young and they had two children. He later married Hazel Williamson, to whom we are greatly indebted for making possible this collection of Sydney's drawings.

Sydney first came to Scotland in his early years. His prep school teacher was from Heriot and he stayed with him during the holidays. His sister's nannie was from Moniaive and both children went to stay there, where Sydney learned of kids' gangs, gang huts, and was no doubt an uproarious child stimulated by the freshness of the Scots tongue to his keen ear. That is where he got his Scots background. Moniaive was as important to him then as Plockton was in later years. His parents seldom came home from Egypt. His mother kept all the letters he wrote from school and from Moniaive and they are now with all the other manuscripts in the National Library of Scotland. They refer to granny and uncles and aunts – all of whom must have been related to his sister's nannie. He had no relations there. The important thing is that all these people would have been speaking good Scots. Sydney was called Mac at school – so it isn't surprising that he chose to write in Scots.

Sydney's mother kept his first painting, describing it so. She also kept many drawings and sketching books from his school days. Hazel, Sydney's widow, has these now, the earliest one from the age of 12 and 13. A very early portrait of his father is titled 'Daddy' in a much less confident hand than the drawing. The sketch of a girl's head and the slim figures illustrated are very confident, and show an interest in the figure and in dress and fashion design that comes up repeatedly through his early work. These fine examples are repeated many times in the books. He is already into the nonsense work with his army caricature and rhyme.

Sydney had absolutely no boastfulness about the great things he achieved but loved to boast about boyish triumphs. He took a first prize in building

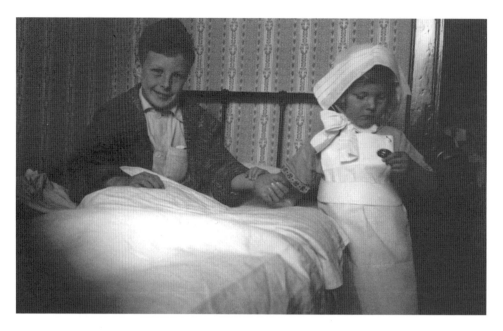

SISTER BET AND SYDNEY.

Meccano. His certificate exists and the prize-winning car he built is now in the Museum of Childhood in the Royal Mile, Edinburgh. It was one of the many endearing things about Sydney that all through his creative and rich life he was at almost any time able to pause and then boast about his knot tying expertise, or about building Meccano or some such apparently wild irrelevant skill. His life was all connected. I have a little Dinky Toy Morris Cowley model, one with a dicky seat, that was Sydney's. Agnes, who was then my wife, had admired it one evening and Sydney gave it to her. He then went and bought another for Hazel has one too. These were and are still, precious little things.

See now his chemistry notebooks from his first year in medicine at Edinburgh. In the collection of poems *Gowdspink in Reekie*, Sydney is of course talking of, and to Oliver Goldsmith reminiscing of life in Reekie's pubs – the Eagle then, the Ensign Ewart nou "back o' the Assembly Hall Whar douce meenister men foregaither" and suddenly . . .

– Guid life, I've mindit why ye cam
Til Embro nou, mine Ollie, antient fiere!
It was Medicine ye were studying,
As aince I did mysel, at Embro tae –
Ay, but ye stuck it langer far nor me!
A towmond and a hauf ye ran
And me juist twa-three terms, for shame!
– But ye can see there's a kind o' bund
Atween us twa, gangrel buddies surely,
Ay, but bards forbye, I'd hae the world ken –
And if they dinnae, mair's their loss
No ours, Ollie, for nocht we hae to tine
(Guid kens) and yon's a fact
That's incontusaboll at last, at least – or even best.

(Collected Poems, p.222)

When Sydney sat his first Anatomy examination, and before he got the results, the procedure was that all corrected papers were put before the Dean, who was of course Sir Sydney, to be countersigned. Between seeing the papers and the results being placed on the board Sydney's father asked him how he thought he had done in the Anatomy examination – "Fair father, fair..." "Do you call 5% fair?"

The medical note-books were kept no doubt for the frivolous and humorous contrast juxtaposed on the pages. Girls with frilly underwear, musicians, dangling ear-rings and the shape of lips vying with chemical formulae. The racing car appears several times but there no aeroplanes. That seems strange when you consider the period with Imperial Airways developing world flying routes, and sporting and war plane development closely linked.

Education following medical school took him furth of Scotland. He had wanted to go to Art College but that wasn't allowed. During Sydney's early stay in Edinburgh doing medicine, he first made friends with Denis Peploe, John Guthrie, Donald and John Beaton, and many others who were pleased to welcome him back years later.

As a poet, Sydney strode right over the many divisions which have

characterised Scottish literature. He appreciated worth when he saw it, and was friendly with many mutual foes, refusing to reject one for the sake of siding with another. In return he was loved by all the poets, whether English writing like Norman MacCaig, Scots like Robert Garioch and Tom Scott, or Gaelic like Sorley MacLean.

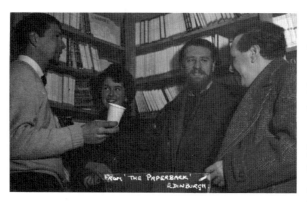

Sydney also loved and was loved by MacDiarmid - "beluved by Hugh that's beluved by me/and baith of us loe the barley bree."

He is renowned as the poet of the love lyric, and of the joys of drinking and camaraderie but the scope of his work goes beyond this to war, social comment, politics, humour, and sometimes, in lengthy asides in what is a love lyric, we can be in strange places. *Under the Eildon Tree* has fine examples of this. Both in the work, and the human being, we find a sense of wholeness, a refusal to say no to life, a fundamental sympathy with other creatures, human and otherwise, and an incredible sense of humour. Clowning was a specialty. Sorley MacLean has said he had the full range of humour from "rapier wit to sheer buffoonery". Certainly there is no shortage of people who remember as a high point of their lives one of those nights drinking with Sydney, which went on until the dawning of the next day and beyond.

"Death to the French" Sydney would say as a form of toast. Where the expression came from I don't know, nor the one he used when a party was slowing up and the glasses were empty: "What did the Governor of North Carolina say to the Governor of South Carolina?" To those who needed an answer, it was: "It's a damned long time b'tween drinks".

I had been travelling with Sydney out to the remotest corner of Wester Ross to look at a derelict cottage at Badluarach – the idea of a West Highland house appealed briefly to Hazel and Sydney – and we were returning to Edinburgh by train. At that stage in my life, and having been visiting several jobs, I was travelling with a First Class ticket. Sydney had come north on a

24

Second Class ticket, so I graciously invited him to join me in my compartment, pointing out that I would explain to the ticket collector. We must have been about Pitlochry or Dunkeld when the ticket man arrived, and were both asleep. I explained that I had invited Sydney to join me for a word. "We can turn a blind eye tae a wurd," he said, "but he was sleepin'." So I had to stump up the difference. The blind eye to a word appealed!

When did I first meet Sydney? I wonder. I don't remember even the year but I do recall that one of his books of poetry was published just that day and we were in the Abbotsford in Rose Street. Sydney inscribed a copy to three of us, friends together, all involved in architecture: from a "bigger of poems". I never saw that book again from that day to this. However, I'm sure I didn't buy it and I doubt if John Reid did either, so it must have been our third, Jack Cartwright's copy. He died only recently. I think the collection was *Cokkils*: Poems (Macdonald 1953)

Cokkils

Doun throu the sea
 Continuallie
A rain o' cokkils, shells
 Rains doun
Frae the ceaseless on-ding
O' the reefs abune
 Continuallie.

Slawlie throu millenia
Biggan on the ocean bed
Their ain subaqueous Himalaya

Wi a fine white rain o' shells
Faa'an continuallie
 Wi nae devall.

Sae, in my heid as birdsang
Faas throu simmer treen
Is the thocht o' my luve
Like the continual rain
O' cokkils throu the middle seas
 Wi nae devall –
The thocht o' my true-luve
 Continuallie.

To those who know the poetry of Sydney Goodsir Smith and to those who have familiarity with his watercolours, the New Auk Society adds this considerable dimension of our knowledge of Sydney. The perception, wit, power and extremely sensitive, delicate line are all shown in this collection made from his known drawings.

It is with an early show of developing Nazi Germany that we first come to the mature drawing. When he was nineteen he had a long tour in Europe. In Bavaria, Berchtesgaden, Garmisch, Oberammergau and Munich all feature. This was the year before the Olympic Games in Germany when Hitler took the world stage, attempting angrily to promote the glory and superiority of the Aryan races as he defined them against the run of successes by coloured athletes in Germany. The Winter Olympics took place at Garmisch in Bavaria. Sydney's wonderful critical assessment of German youth, inflated with gross political prejudice is clear. His gullumphing hob-nail booted chap dances with the girl in National dress, breaking the rules clearly displayed, and Christ on the cross is the alternative symbol to Adolf Hitler, forcefully contrasted as they hang on the walls of the Berchtesgaden cafe. Was it known that Hitler had his bunkered hide-out in the mountains above Berchtesgaden at that time, I wonder? The swastika is everywhere and the characters thoroughly unpleasant with the exception, perhaps, of the elegant Munich interior with its gentle music, and the couple on the lake.

Italy is much less aggressive but there is a jokey menace in the Guardian of the Basilica, Piaza san Marco. There is perceptive observation of the many characters in Harry's Bar, the monk, the gondoliere, all in sharp focus. It is the nature of Venice. For all the amazing architecture – The Rialto Bridge and the magnificent palaces rising straight out of the water, San Giorgio Maggiore across the lagoon – it is the

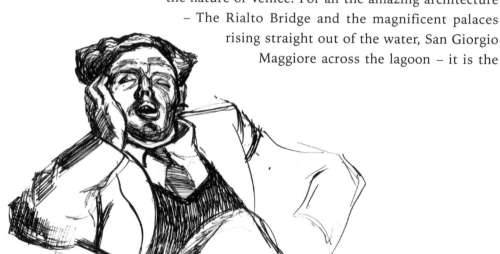

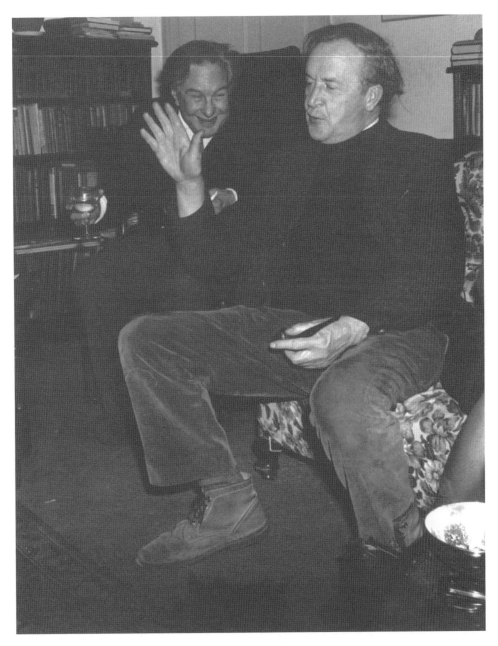

SYDNEY WITH SORLEY AT DRUMMOND PLACE

PHOTO: GORDON WRIGHT

individual face that stands out in my own recollection of Venice.

Sydney's drawing of the Rialto Bridge is splendid. The drawing of the little stone Bacchus figure sitting naked on the shell of the tortoise in the gardens behind the Pitti Palace, Florence, may not be exceptional – but imagine one night late, with friends in the house in Edinburgh maybe talking about Florence, or something that points the memory, and out comes the old sketch book of drawings done maybe forty years before. In a splendid gesture Sydney tears out the page with the little figure and brings it right up to date with a special message for Anna, Emeritus Professor of Brewing and a close neighbour and friend, writing "quo' he (Water is best) but who believes him! Eh Anna?"

The notebooks have many pages removed. Maybe some other drawings of that holiday now lie unremembered or unrecognised.

Sydney obviously enjoyed that holiday. Paris follows and was quite simply fun. How different from Bavaria!

What a robust Bacchanalian spirit, always ready to recall events or comments connected with the rich social life, warm-spirited and outstandingly friendly. There is a story of Sydney sitting on a tramcar when a chap with a good drink on him came on and staggered along the car, swinging himself into the seat in front, muttering and trying to turn round to address Sydney. Eventually he got himself properly turned round and made the big statement: "You know," he said to Sydney, "I'm not a drinker – no, I'm a drunkard!" That direct honesty, whether true or not, was what made life real and big and Sydney had compassion for all sorts of people.

I never knew, nor did I ever hear of Sydney being the worse for drink. The better, certainly and often. He was never aggressive but had strong views and opinions, and he worked at life. He made life. Weekends were his ebullient time, Bacchanalian perhaps but he was no god immune to hangovers and the problems of the morning after which afflict mortals.

I heard Sydney say that he very much regretted that at an early stage in his life he had failed to persuade his father to buy, I think, one Rouault painting which was for sale at a low price. On one occasion I went on an expedition with Sydney to a sale of paintings to buy one for a hotel job we were doing. We bought a Naysmith for the job and Sydney got a portrait of Byron.

Everyone was satisfied. Sydney thought of many ways to make money. The big idea, however, that didn't get off the ground, was his proposal that we collectively – as many as liked to join in – buy a small flat in Yoker or Partick; somewhere right beside the docks on the Clyde. This was long before the popularity of bottled water, when few had even heard of Vichy water – but Sydney's idea was that we would sit in Glasgow at the kitchen window filling bottles from the sink tap, put them into cardboard boxes and run them round to the ships that would take the fresh water of Loch Katrine worldwide. The ships that carried the whisky could carry our stuff to put with the whisky wherever it was to be drunk. From the home of the mountain and the deer! I'm sorry that there is no sketch for a label for the bottles, but many here would have done. We might have cornered the world market! Certainly possible with Sydney's wonderful optimism and enthusiasm.

Plockton was and is a splendid colourful place, particularly at regatta time with the boats silently moving under sail across the water in the races. There are many watercolours of this scene. The children lined up on the shoreline with their home made and specially decorated sails on the grown-ups' boats, displaying them for the prizegiving after the Ragamuffin race on the Saturday after the closing evening of the Regatta Concert is another colourful scene. That was a masterstroke of organisation, to establish the highlight of the childrens' day in the early afternoon after the traditional late night round of the village after the concert. The concert is a pretty stiff affair for the most part, with the 'deep sea choir' sometimes almost embarrassing as the local men – joiners, masons, shopkeepers

SYDNEY AND HAZEL

29

– do the formal bit on stage. Sydney would of course be there enjoying the fun, embarrassment or not. In sketches, Sydney has the music jumping from the paper – the fiddler and accordions, and the piping of Torquil on the platform of the village hall. The pennant on the wall is of the Plockton Small Boat Sailing Club, established about sixty years ago.

I mind a night in Plockton Hotel. A visitor to Plockton who had spent much of the previous night upstairs in his bed aware of the muffled buzz from downstairs decided that this night if he wasn't going to sleep, he was going to be with the company downstairs. He was welcomed. Mr. Wood was on holiday from England, a fine character who was given temporary status in Sydney's college of cardinals as 'de Bois'.

The place was ministered from a semicircular pulpit around which no bottles or drink of any kind was displayed and Buachan, Murdo was his own name, was el Papa. He appeared within this pulpit on call and dispensed the ordered drams and beer. I don't remember why we were reduced to drinking bottled Export with the drams, but it was fine enough. Sydney had a habit of using a pencil as a swizzle stick to remove some of the gas from bottled beer! During the evening Sydney got into an extended and very infectious laugh. It turned to coughing, and he fumbled deep in his jacket pocket for his 'puffer' (inhaler). It wasn't there or anywhere around. Sydney had been on the shore before going to the hotel so out we all trooped in the pale light of the late summer night to look for this precious device on the pebbly Plockton beach. What a curious sight it must have been, the hale college o cardinals and the lower orders oot there, and Sydney quite distressed. With enormous relief

and pleasure I luckily found the thing. Back we all moved into the Hotel and I was given promotion – maybe it was to bishop or archbishop; and el Papa dispensed another round. What full rounded warmth there was in these evenings. It was an amazing 'hauspotible' place, right enough.

The spirit of course carried with Sydney wherever he went and it is in his poems. Here in Edinburgh – 'To Li Po' takes us to the Abbeymount where, over the way:

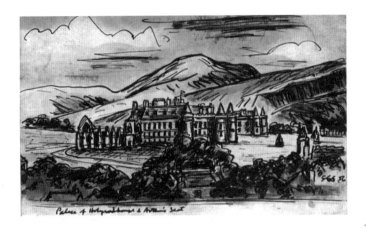

In the Palace, down ablow,
The ae lane yalle licht aye glents.
Glinkan like a coorse madame –
An damn the delyte has she in-ben!. . .
The nicht was ourie richt eneuch;
But nocht we felt the drowie rouk
Bane-cauld, or the weet – or ocht
Ither, as I can mynd –
Hame with mirrilie up the brae
Wi a hauf-mutchkin and hip-pint,
And screwtap chasers clinkum-clankum
In tune wi our maist important bletherin,
Our maist significant piss-and-wind . . .

– While the world in its daith-dance
Skuddert and spun
In the haar and wind o space and time
Wi nane to accolad the goddess-mune,
Invisible, but her foredoomed elect:
The bards, the drouths, the daft,
the luvers,
We!
– Ay, here was aa wir companie,
Tinks and philosophers,
True Servants o the Queen.

(*Collected Poems*, p.103)

There is a good drawing of the Scott Monument on Princes Street, Edinburgh, blackened by the soot of the railway locomotives and tenements of Old Reekie. It is remarkable that this small and relatively poor country has raised one of the world's greatest monuments to a man of the arts, and we built it! Look from the Old Town and you see this splendid Gothic

monument, a truly old town symbol, plonked down defiantly at the foot of St David's Street. It is dark, and has some of that same chaotic sense of grandeur that the Old Town has – a splendid contrast to the elegant formality of the Georgian New Town. There is a move to clean the monument and make it look 'better' – I like it, looking as it does, dark like Sydney's drawing.

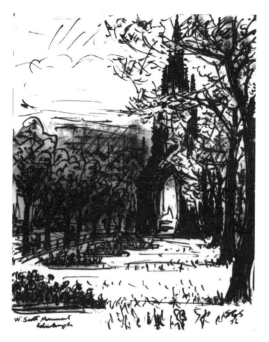

W. Scott Monument
Edinburgh

Sir Walter Scott says in his writings "If I did not see heather once a year – I think I should die!" At the annual laying of the heather wreath at the Monument on Princes Street, Sydney questioned "I wonder who she was?"

There are many jokes about Sydney – some are imaginary, told by himself. This is a true one based on an occasion when Sydney loaned a cheque to a friend in an Edinburgh bar. Unfortunately the cheque bounced and the affair was taken to court. Sydney was summoned to appear to identify the chap who bounced the cheque and also to identify the cheque. When he arrived at court there were lots of kent faces, owners of pubs who had taken cheques from this same chap and had them bounce. Sydney made a party out of the occasion and went round identifying the individuals with their establishments: Jack Grant of the "Abbot", Bob Watt of "Milne's", Mrs Crossan of "Crossans", another of the "Canny Man" but he came to one he knew but couldn't place or name. He asked which establishment he was from? ... "Mr Smith, I am your bank manager."

Once, I had illustrations of a school we had designed on the West Coast hanging at the Royal Scottish Academy Summer Exhibition. Sydney noted in *The Scotsman* "Shades of the prison house". He later said to me that the photographs weren't good enough! I didn't thank him for that!

My contact with Sydney was not continuous but it is astonishing how we did coincide. The year after my partner, Robert Hurd, died, I had to work long hours and it was not possible for my family to take a normal holiday. We decided to take a taxi to Leith and get on the boat, the St Magnus, heading for Shetland. The first day was spent

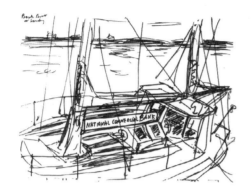

in Aberdeen. In the town we bumped into Sydney and Hazel. They were going on the same boat to Kirkwall! So we sailed that afternoon northwards together again.

There is more than one visit to the Northern Isles recorded in Sydney's northern drawings which follow, and the quality of the drawing and the atmosphere evoked is exciting. Boats or ships, ferry boat, coal boat, sailing boats or even the Bank boat, there is a total feel for the form of seagoing craft. This was obvious too in the early drawings of the gondola, probably the most of subtle of all boats. In the notebooks, one page is given to a handwritten copy of one of the brass plates that give notice to persons on board ship. This is from the "Earl Sigurd":

The Deck from the Bulkhead at Aft End of the Bridge to 6.6 feet aft of the deckhouse contains 326 square feet and is certified for 36 1st class Passengers when not occupied by Cattle, Animals, Cargo or other encumbrances.

When Elizabeth, our secretary in the office many years ago, was leaving to have a baby, we wanted to give her a present. Because she liked visiting the North West Highlands I asked if she would like to choose a watercolour by Sydney Goodsir Smith. An appointment was made and one lunchtime we went to the Dundas Street flat. A picture was selected and I was writing a cheque, £25 I think it was. Elizabeth was obviously watching me write it, slightly worried, or maybe it was embarrassed? when Sydney, watching her, said "Don't worry lass, not a penny of it will be wasted – it'll all go on drink!"

Sydney was never bad-tempered or rude. There is a postcard of one of Sydney's drawings illustrating the Vennel in Edinburgh. There is even a little poem on the back, written for Bob who sold papers on the street. Somehow the card was never delivered but the intention was obvious.

Sydney's normal day was fairly well structured. He rose late but worked on the typewriter doing his routine work – articles, letters and such until the water was steaming hot for his daily bath. Lunchtime was time off. Afternoons he read, including his newspapers and magazines. Politics and the Scottish movement for independence were always of interest and he took, apart from the daily papers, the *New Statesman*, the *Spectator*, the *Times Literary Supplement* and all the poetry magazines - the *Saltire Review* in its day; *Lines Review* from the very start; *Akros*; – *Chapman* too in its early years.

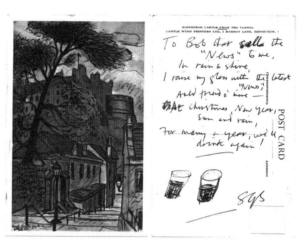

From about 7.30 in the evening work stopped and there were drinks normally about 9.30 - 10.00. Weekends were different. Of course if Sydney was working on a poem or a deep thinking piece then time ceased to matter and he would work often very late.

As many people do who suffer from asthma, Sydney had pretty severe eczema and did not like this to be noticed. Bandages wrapped round his forearms to protect the skin from rubbing by his tweed jacket occasionally slipped and he did not like comment on these bandages, however innocently made. Yet his "puffer", the life inhaling device to give him breath, was totally accepted, openly administered and often the subject of fun. He was a cigarette smoker too, which cannot ever have been good for him, but it was part of the good life. Sydney digging deep into his big pockets for his fags or his matches or his puffer leaves an extraordinarily strong impression in the mind.

In 1985, a few of us working with the Heritage Society put on a show at the Edinburgh International Festival in the Art College. Joy Hendry, Billy Wolfe, Robert Calder and I did a piece drawing together a story about Sydney, readings from his poems and a show of slides made from some of his drawings. Hazel, Sydney's widow, afterwards suggested that we publish the drawings we had shown. She had enjoyed it very much. *The Scotsman* critic left after the first half of the show so missed the whole bit about Sydney – he now has another opportunity to see the drawings!

The drawings illustrated are a selection from twelve notebooks in safekeeping at the National Library of Scotland together with a few from private collections.

Sydney's greatest work, possibly, is the long poem *Under the Eildon Tree*. It was first published in 1948 but was later published in 1949 in revised form as 'A Poem in Twenty Four Elegies'. One elegy was added and there was some reordering. Sydney did drawings, illustrated headings, to eleven of the elegies. These follow with the appropriate fragment of the full work alongside. The drawings have not been published before, except for a small sampling which appeared together with an article by me on the drawings in *Chapman 55-6* (1988). This is not a new publication or revision of the poem. The drawings are from 1947 and there are discrepancies in the numbering of the drawings to the Elegies in the 1954 revision.

As an architect, fascinated by our traditional architecture and the spirit still retained in a place like old Edinburgh, I find the vigour and vitality of a piece like 'The Black Bull' bursting out from both poem and drawings, is splendid, wild, irreverent stuff. It is important, I believe, to see the full rounded quality of Sydney's work. The drawings are distinct but they are also very much part of the whole, like the words and phrases that are entirely and characteristically Sydney.

His play *Collickie Meg* is still unpublished. It is very robust and funny. Collickie Meg is Mother Earth and her daughter Aphrodite is born from a shell on Portobello beach: "Aphrobridgetie Dampobottomey Bride, known as 'Biddie' – Quok the Auk".

I wish that our architecture today was motivated with such energy and courage, and such humanity as we have in this work of Sydney.

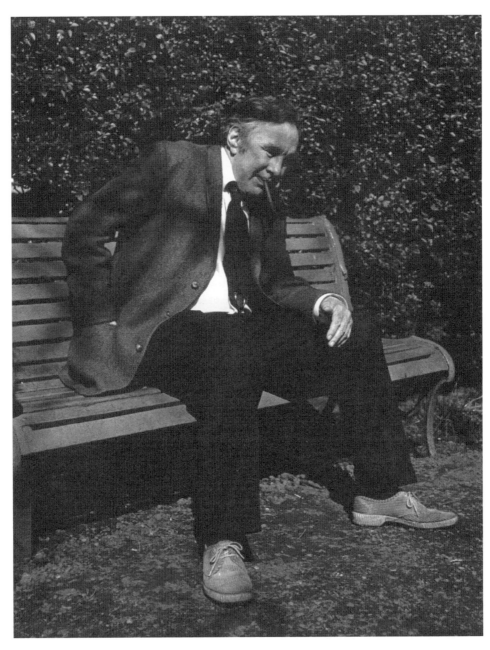

SYDNEY IN DRUMMOND PLACE GARDENS

PHOTO: GORDON WRIGHT

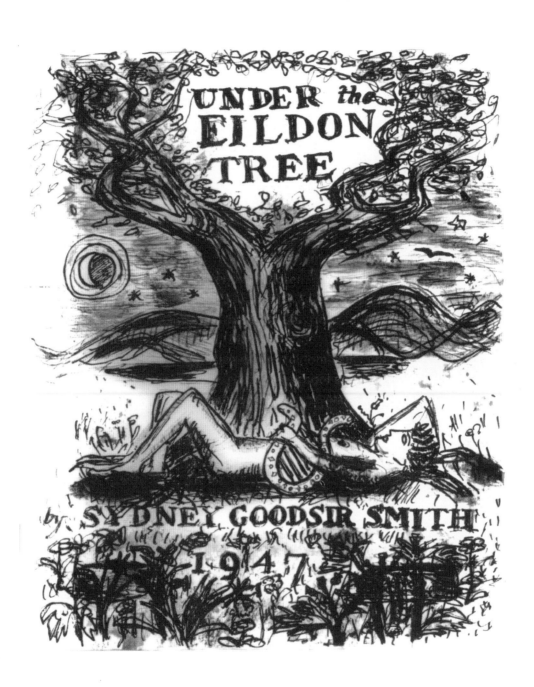

UNDER the EILDON TREE

by SYDNEY GOODSIR SMITH
1947

I

From *Under the Eildon Tree*

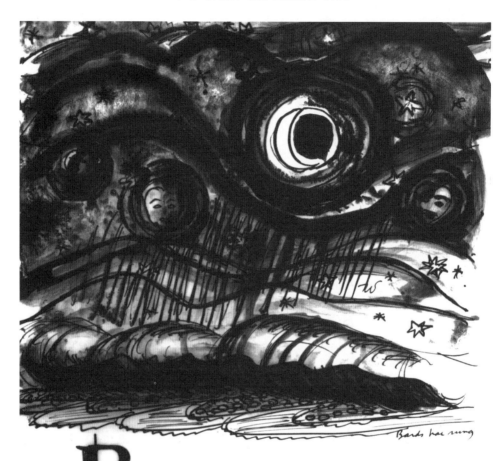

BARDS hae sung o lesser luves
 Than I o thee,
 Oh my great follie and my granderie,
 That nane kens but anerlie thee.

Aa the haars that hap the yerth
 In jizzen aince again,
 Swirlan owre the warld
O' the centuries' great poesie,
 Can smore the names of aa,
 Aa memories –
But yours, Ward o black-maned Artemis,
The Huntress, Slayer, White Unmortal Queyne,
 That aye sall byde undeean
 In this the final testament
 Infrangible as adamant –
 O' this dune bard afore
 His music turns to sleep, and
The endmaist ultimate white silence faas
Frae whilk for bards is nae retour.

IV

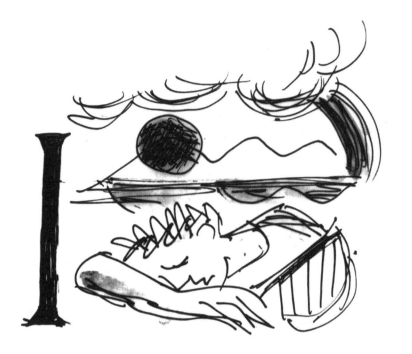

I, LUVE-DOITIT bard o the Westren Warld,
That saw but coudna win
The Fortunate Isles ayont the Westren Sun
Forge this last testament to stand
Heroic wi the tale o Helen, Cleopatra, Lesbia.
Wi Morfydd, Dido, Heloise,
And Mary o the whitest blee,
As Rab his Mary, Hugh his Jean,
Sae I nou sing o thee,
My ain Perdita, Phryne, Cynthia.

Aa yon bonnie cruel thrang
O' wemen lit unmortal luve
For bards to fleer the gods wi pride
And tak the lowes o hell for cauldrife comfortin!
Sae I here enumerate
In yon fell companie for thee,
My torment and my exstasie,
Whas like disdain teuk me,
Held me and gied me Paradise enow
For aa the gowden green Hesperides were mine
– For nocht but fulerie.

Och weill, it was your richt, I ken,
To gie, syne to withhaud again,
My grail I got and it was taen
Was it no yours til tak again?

Enumerate amang the legion o the damned I tak
My leave here in this endmaist coronach –
Salud!
Fareweill!
And syne the sleepless, waukless, dawless nicht
O' life in daith
And daith in daith.
(Cliché!
Echo answers Clichy!
Whar the debtors went in gay Paree!
O God! O Montrachet!
O Arthur's Seat!) But Daith!

V

Here I ligg ,Sydney Slugabed Godless Smith.
The Smith, the Faber, poihths and Makar,
　And Oblomov has nocht til lear me,
　Auld Oblomov has nocht on me,
　Liggan my lane in bed at nune,
　Gantan at gray, December haar,
　A cauld, scummie, hauf-drunk cup o tea
At my bed-side,
　Luntan Virginian fags
– The New Warld thus I haud in fief
And levie kindlie tribute. Black men slave
Aneth a distant sun to mak for me
Cheroots at hauf-a-croun the box.
　　Wi ase on the sheets, ase on the cod,
And crumbs o toast under my bum,
Scrievan the last great coronach
O' the Westren flickeran bourgeois warld.
　　Eheu fugaces!

　　　　　　Lacrimae rerum!
Nil nisi et cetera ex cathedra,
　　　　　Requiescat up your jumper.

Oh michtie Stalin i the Aist!
Coud ye but see me nou,
The type, endpynt and final blume
O' decadent capitalistical thirldom
　　– It teuk five hunder year to produce me –

42

Och, coud ye but see me nou
What a sermon coud ye gie
 Furth frae the Hailie Kremlin
Bummlan and thunderan owre the Steppes,
Athort the mountains o Europe humman
Till Swack! at my front door, the great Schloss Schmidt,
That's *Numéro Cinquante (piat, desiat*,* ye ken)
I' the umquhile park o Craigmillar House
Whar Mary Stewart o the snawie blee
Aince plantit ane o a thousand treen.
 Losh, what a sermon yon wad be!
For Knox has nocht on Uncle Joe
And Oblomov has nocht on Smith
 And sae we come by a route maist devious
 Til the far-famed Aist-West Synthesis!
 Beluved by Hugh that's beluved by me
And the baith o us loe the barley-bree –
But wha can afford til drink the stuff?
 Certes no auld Oblomov!
 – And yet he does! Whiles!
 But no as muckle as Uncle Joe – I've smaa dout!

Na zdorovye° then, auld Muscovite!
Thus are the michtie faaen,
Thus the end o a michtie line,
Dunbar til Smith the Slugabed
Whas luve burns brichter nor them aa
And whas dounfaain is nae less,
 Deid for a ducat deid
By the crueltie o his ain maistress.

 *Fifty °Good Health

43

VIII

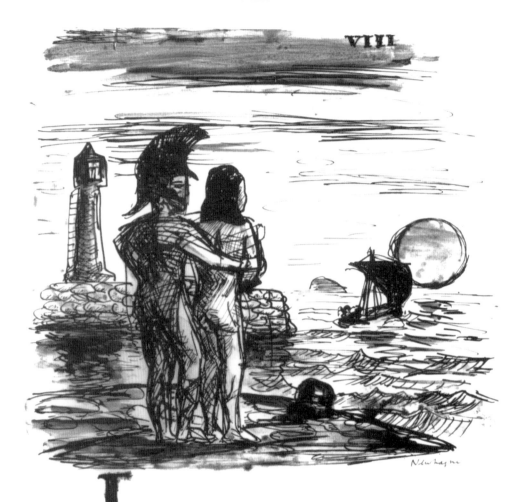

I had a luve walked by the sea,
The waterfront at eenin,
Sol was a gowden pennie at our side
A bare league awa.
A wee boat wi a broun sail
Left the pier juist at our feet
And sailed awa intil the sunset

Silentlie, the water like a keekin-glass.
We spak nae word ava.
My luve turned til me wi her een
Owre-rin wi greit, and mine
Were weet wi the like mysterie.
We stude by the Pharos there
A lang while or the sun dwyned doun
And the gray-green simmer dayligaun
Closed about the hyne.
Syne it grew cauld, and in my airms
I felt her trummlan
Wi the like undeemous mysterie did steek
My craig, sae that I coudna speak.

X

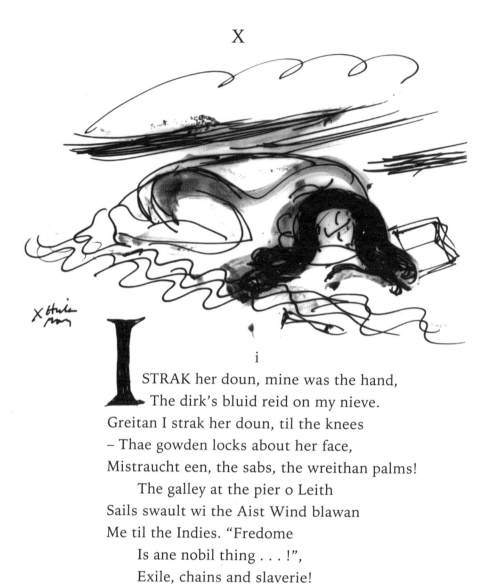

i

I STRAK her doun, mine was the hand,
 The dirk's bluid reid on my nieve.
Greitan I strak her doun, til the knees
– Thae gowden locks about her face,
Mistraucht een, the sabs, the wreithan palms!
 The galley at the pier o Leith
Sails swault wi the Aist Wind blawan
Me til the Indies. "Fredome
 Is ane nobil thing . . . !",
 Exile, chains and slaverie!
 – Och, what the hell!!

"Ye banks and braes and streams around
 The Castle o Montgomerie . . ."
– Its aa i the texts, the gifts were gien,

46

The gifts were taen. The glune,
 The Bible, bluid –. Aa this is kent.
The pacts and kisses and fareweills
 – And I richt back til bonnie Jean!
 Naxos for Ithaca – What then!

Ah, but the guilt, the ower-impendant wings,
Bluid-wyte at the hert like leed
 – What then, indeed?
The Channeran Worm doth chide
And aye sel-kennin brings
Hert-thraw – and the guilt again.
 Aye the tint luve leams
Mair brichter for its bein tint.
Distance, ye ken, enchantment . . . et cetera.

47

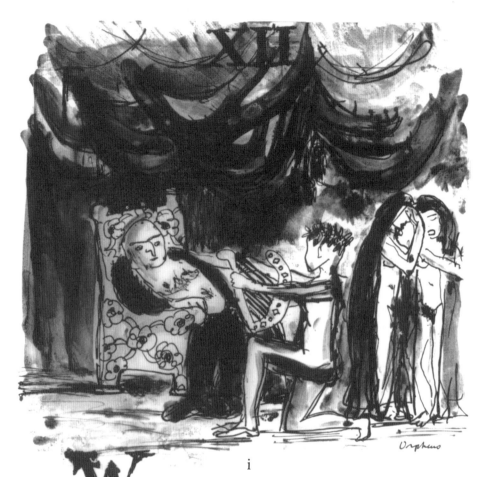

i

I sang aa birds and beasts coud I owrecome,
 Aa men and wemen o the mapamound subdue,
The flouers o the fields,
Rocks and trees, boued doun til hear my leid,
Gurlie waters rase upo the land to mak
 A throwgang for my feet.

I was the potent prince o ballatrie,
My clarsach opened portes whareer I thocht to gang,
 My fleean sangs mair ramsh nor wine
At Beltane, Yule or Hogmanay
 Made wud the clans o men –
There wasna my maik upo the yerth
 (Why suld I no admit the fack?)
A hero, demi-god, my kinrik was the hert,
 The passions and the saul,
 Sic was my pouer.
Anerlie my ain sel I coudna bend.

 "He was his ain warst enemie,"
 As the auld untentit bodachs say –
 My hert, a leopard, ruthless, breme,
 Gilravaged far and near
Seekan sensatiouns, passions that wad wauken
 My Muse whan she was lollish.
No seendil the hert was kinnelt like a forest-bleeze . . .
I was nae maister o my ain but thirlit
 Serf til his ramskeerie wants
– And yet I hained but ane i the hert's deepest hert.

 She, maist leefou, leesome leddy
 – Ochone, ochone, Euridicie –
Was aye the queen of Orpheus' hert, as I kent weill,
 And wantan her my life was feckless drinkin,
 Weirdless, thieveless dancin,
 Singin, gangrellin.
 – And nou she's gane.

49

ii

The jalous gods sae cast my weird that she
Was reift intil the Shades throu my negleck.
 I, daffan i the groves and pools
 Wi the water-lassies,
 Riggish, ree, and aye as fain
 For lemanrie as Orpheus was,
I never kent o her stravaigin,
 Lane and dowie i the fields;
Nor that yon Aristæus loed my queyne.
 It was fleean him she deed
But yet was my negleck that did the deed;
Neither was I by her to proteck
 Frae the dernit serpent's bane
Green and secret i the raff gerss liggan
– I was her daith as she was life til me,
 Tho I was feckless born and lemanous
Yet she was mair nor aa the daft ree nymphs
 O' wuid and burn til me
 –Yet it was I
 That flung Euridicie
The aipple o my bruckle ee
 Til yon far bourne
Frae whilk, they said, theres can be nae retourn.
 "Quhair art thow gane, my luve euridicess?"

50

iii

Ye ken the tale, hou, wi my lute
 I doungaed amang the Shades
(Gray mauchie Hades, lichtless airt)
And Pluto and the damned stude round
 And grat, hearan my sang;
Hou, haean wan her manumissioun
Frae the Profund Magnifico,
I, cryan her name, socht and fand my luve
 Amang thae wearie shadaws,
 Yet tint her i the end.
 For her a second daith,
 For me a second shame.

 (The sycophantic gods, ulyied and curlit,
 Reclynan i the bar on bricht Olympus.
 Soupan their meridian, outbocked
 Their lauchter like a tourbilloun
 At this the latest ploy o Zeus
 The Caird, the Conjuror, the aye-bydan
 Favourite and darlin o them aa,
 The Wide Boy – *ex officio!* – the Charlatan!)

She stummelt on a bourach, outcried "Orpheus!"
– Een, what wey were ye no blind?
– Lugs, what wey were ye no deif?
– Hert, what wey were ye no cauld as ice?
– Limbs, what wey were ye no pouerless?
– Harns, what wey did ye no haud the owerance?

(And Jupiter, in order til extraict
The maist exquisite quintessence
O' the succulence o his wee ploy
And wi his infantile perfectit sense
O' the dramatic, kept this impeccabil
And maikless agonie,
As a *bonne-bouche*, til the end.)

We werena ten yairds frae the bank o Styx
The ferryin o whilk was luve and libertie
 – No ten yairds awa!
Our braith was hechlan and our een
 Glaizie-glentit wi the joy
 Of our twa-fauld deliverance –
And than Jove strak wi serpent subtletie.
 Euridicie stummelt.

 (Lauchter cracked abune. Jupiter leuch!
 – And richtlie sae!
 Och, gie the gods their due
 They ken what theyre about.
 – The sleekans!)

She stummelt. I heard her cry. And hert ruled heid again.
– What hert coud eer refuse, then, siccan a plea?
 I turned –
 And wi neer a word,
 In silence,
Her een yet bricht wi the joy o resurrectioun,
She soomed awa afore my een intil a skimmeran wraith

And for a second and last time was tint for aye
 Amang the gloams and haars o Hell
 – Throu my ain twafauld treacherie!
 "Quhair art thow gane, my luve euridicess?"

 iv

Sinsyne I haena plucked a note
 Nor made a word o a sang,
The clarsach, and the lyre, the lute,
 'The aiten reed',
Byde untuned in a yerdit kist.

My taiblets aa are broke, my pens brunt,
 The howff sees me nocht
 Nor the lassies i the glen.
 The hert in my bosom's deid
 For Euridicie is deid
And it was I that did the double deed,
 Twice-cursit Orpheus!

I gang til jyne her i the skuggie airt,
A convene fou o dreid for Orpheus' hert.

 Aa this will happen aa again,
 Monie and monie a time again.

 (*Explicit Orpheus.*)

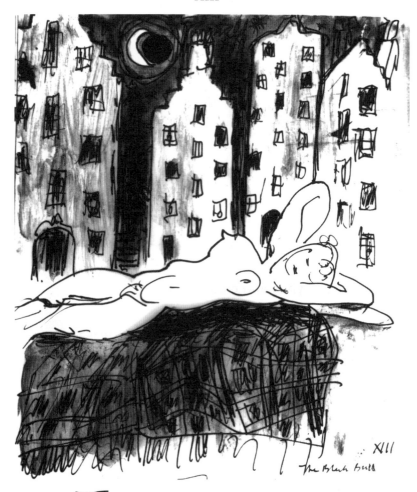

I GOT her i the Black Bull
 (The Black Bull o Norroway),
 Gin I mynd richt, in Leith Street,
 Doun the stair at the corner forenent
The Fun Fair and Museum o Monstrosities,
 The Tyke-faced Loun, the Cunyiars Den
 And siclike.

I tine her name the nou, and cognomen for that –
Aiblins it was Deirdre, Ariadne, Calliope,
Gaby, Jacquette, Katerina, Sandra,
 Or sunkots; exotic, I expeck.
A wee bit piece
 O' what our faithers maist unaptlie
 But romanticallie designatit 'Fluff'.
My certie! Nae muckle o Fluff
 About the hures o Reekie!
Dour as stane, the like stane
As biggit the unconquerable citie
Whar they pullulate,
 Infestan
The wynds and closes, squares
And public promenads
 – The bonnie craturies!
 – But til our winter's tale.

ii

Fou as a puggie, I the bardic ee
In a fine frenzie rollan,
Drunk as a fish wi sevin tails,
Purpie as Tiberio wi bad rum and beerio,
 (*Io!* *Io!* *Iacche!* *Iacche, Io!*)
– Sevin nichts and sevin days
 (A modest bout whan aa's dune,
 Maist scriptural, in fack)
Was the Makar on his junketins
 (On this perticular occasioun
 O' the whilk we tell the nou

Here i the records, for the benefit
O' future putative historians)
Wi sindrie cronies throu the wastage-land
O' howffs and dancins, stews
And houses o assignatioun
I' the auntient capital.

–Ah, she was a bonnie cou!
Ilka pennie I had she teuk,
Scoffed the halicarnassus lot,
As is the custom, due
And meet and mensefu,
Proper and proprietous,
 Drinkan hersel to catch up wi me
 That had a sevin-day stert on her
 – O' the whilk conditioun
Nae smaa braggandie was made at the time
Here and yont about the metropolis –
 And mysel drinkan me sober again
For reasouns ower obvious
Til needcessitate descriptioun,
 Explanatioun,
 Or ither.

Nou, ye canna ging lang at yon game
And the hour cam on at length
That the Cup-bearer did refuse
The provision of further refreshment
 – Rochlie, I mynd, and in a menner
 Wi the whilk I amna uised,

Uncomformable wi my lordlie spreit,
A menner unseemlie, unbefittan
 The speakin-til or interlocutioun
 O' a Bard and Shennachie,
 Far less a Maister o Arts,
 – The whilk rank and statioun I haud
 In consequence and by vertue
 O' unremittan and pertinacious
 Applicatioun til the bottle
 Ower a period no exceedan
 Fowr year and sax munce or moneths
(The latter bean a *hiatus* or *cæsura*
For the purposes o rusticatioun
Or *villeggiatura* "at my place in the country"):
 Aa the whilk was made sufficient plain
Til the Cup-bearer at the time –
 Losh me, what a collieshangie!
Ye'd hae thocht the man affrontit
 Deeplie, maist mortallie
 And til the hert.
Ay, and I cried him Ganymede,
 Wi the whilk address or pronomen
 He grew incensed.
"Run, Ganymede!" quo I,
 "Stay me wi flagons!"
 (Or maybe tappit-hens)
 – But I digress.
It was rum, I mynd the nou, rum was the bree,
Rum and draucht Bass.
 – Sheer *hara-kiri!*

iii

– Ah, she was a bonnie cou!
Saxteen, maybe sevinteen, nae mair,
Her mither in attendance, *comme il faut*
Pour les jeunes filles bien élevées,
 Drinkan like a bluidie whaul tae!
Wee breists, round and ticht and fou
Like sweet Pomona i the oranger grove
Her shanks were lang, but no ower lang, and plump,
 A lassie's shanks,
Wi the meisurance o Venus –
 Achteen inch the hoch frae heuchle-bane til knap,
 Achteen inch the cauf frae knap til cuit
As is the true perfectioun calculate
By the Auntients efter due regaird
For this and that,
 The true meisurance
 O' the Venus dei Medici,
 The Aphrodite Anadyomene
And aa the goddesses o hie antiquitie –
 Siclike were the shanks and hochs
O' Sandra the cou o the auld Black Bull.
 Her een were, naiturallie, expressionless,
Blank as chuckie-stanes, like the bits
O' blae-green gless ye find by the sea.
 – Nostalgia! Ah, sweet regrets! –
 Her blee was yon o sweet sexteen,
Her lyre as white as Dian's chastitie
 In yon fyle, fousome, clartie slum.
Sound the tocsin, sound the drum!

The Haas o Balclutha ring wi revelrie!
The Prince sall dine at Hailie Rude the nicht!

iv

The lums o the reikan toun
Spreid aa ablow, and round
As far as ye coud leuk
The yalla squares o winnocks
Lit ilkane by a nakit yalla sterne
Blenkan, aff, syne on again,
Out and in and out again
As the thrang mercat throve,
 The haill toun at it
Aa the lichts pip-poppan
 In and out and in again
 I' the buts and bens
 And single ends,
 The banks and braes
O' the toueran cliffs o lands,
Haill tenements, wards and burghs, counties,
 Regalities and jurisdictiouns,
 Continents and empires
 Gien ower entire
Til the joukerie-poukerie!
Hech, sirs, whatna feck of fockerie!
Shades o Knox, the hochmagandie!
 My bonie Edinburrie,
 Auld Skulduggerie!
Flat on her back sevin nichts o the week,
Earnan her breid wi her hurdies' sweit.

– And Dian's siller chastitie
Muved owre the reikan lums,
Biggan a ferlie toun o jet and ivorie
That was but blackened stane
Whar Bothwell rade and Huntly
And fair Montrose and aa the lave
Wi silken leddies doun til the grave.
 – The hoofs strak siller on the causie!
 And I mysel in cramasie!

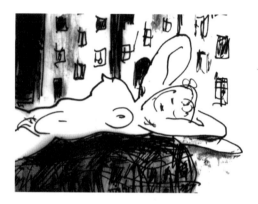

v

There Sandra sleepan, like a doe shot
I' the midnicht wuid, wee paps
Like munes, mune-aipples gaithert
 I' the Isles o Youth,
Her flung straucht limbs
A paradisal archipelagie
Inhaudan divers bays, lagoons,
Great carses, strands and sounds,
Islands and straits, peninsulies,
 Whar traders, navigators,
 Odyssean gangrels, gubernators,
 Mutineers and maister-marineers,

And aa sic outland chiels micht utilise wi ease
Cheap flouered claiths and beads,
Gawds, wire and sheenan nails
 And siclike flichtmafletherie
In fair and just excambion
For aa the ferlies o the southren seas
That chirm in thy deep-dernit creeks,
 – My Helen douce as aipple-jack
 That cack't the bed in exstasie!
Ah, belle nostalgie de la boue!

– Sandra, princess-leman o a nicht o lust,
 That girdelt the fishie seas
 Frae Leith til Honolulu,
Maistress o the white mune Cytherean,
 Tak this bardic tribute nou!
Immortalitie sall croun thy heid wi bays,
 Laurel and rosemarie and rue!
You that spierit me nae questions,
 Spierit at me nocht,
 Acceptit me and teuk me in
 A guest o the house, nae less;
Teuk aa there was to gie
 (And yon was peerie worth),
Gied what ye didna loss –
 A bien and dernit fleeman's-firth
 And bodie's easement
 And saft encomfortin!
O Manon! Marguerite! Camille!
 And maybe tae the pox –
 Ach, weill!

XX

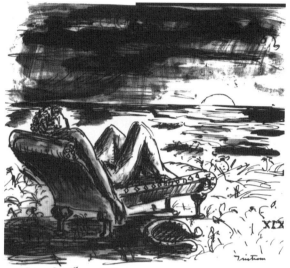

Sae it has come til this i the end –
A barren strand, a skaith, a man bydan at dayligaun
Wi's hert in targats, onwytan a boat's retour;
Aa his dwynan ingyne bund up and concentrate
Aince mair on the outcome o a deean chance,
(Deean in ilka sense o the word!)
– Iseult, Iseult! Name that in my lugs
For a man's life o days and nichts,
The life o bard and warrior, no wi the custom
O' bydan hame o nichts or keepan house by day,
– For him yon name has meant aa that he kens o life,
Iseult that has meant aa life and licht, aa sun or storm,
Howp, wanhowp, hell, but seendil hevin,
Life, and nou but daith –
Sae nou as for the hauflin chiel in Joyous Gard, lang syne,
Aince mair a boat hauds all o Tristram's weird.
Swallow at first and Swan at endin . . .
Swan, whan will ye come til me? White Swan! My Iseult!

– Ah, but i the days o the Swallow I was young and maister
 O' the keys o life (or sae I thocht),
Then, there was howp, and gifna howp then life at least . . .
Now, the howp is smaa and anerlie daith at back o it;
 Neither nae maister I, seik and skaithit dour,
 Dependand on ithers' een, on ithers' hands –
And yet is but the same, for Iseult as aye his weird
 Can mak or mar.

Ay, daith is on me, her cauldrife hand has strak at my hoch
Wi the horn o a muckle hart, lord o the wuids,
 A noble daith at least, or sae they say.
But what til me's nobilitie? Daith is daith.
And life is daith wantan the anerlie life I want,
 – Iseult, my hert's hert . . . Sae what's the odds?

A hart has skaithit me:
 Will the hart bring me my hert
 Here at the endin o a waefu tale?
 – There's a conundrum, Merlin!
It suld be sae, certes, by aa the laws o invocatioun,
Nominomancie, incitement, coincidence and exhortatioun,
 But will't be sae?
– Ay, and heres anither: It was i the chase
My hert first brairit wi the dragon hervest o this luve!
Anither echo! The oracles are guid indeed!

Hou I mynd her yon bricht morn! – Siller and gowd!
– Siller on her bridle and her paufrie's graithin,
– Gowden the chain that held her siller horn,
– Siller her lauch amang the great buck trees,
– Her hair that streamed like a gowden linn adoun her back

63

Bedimmed the gowden band that circelt it,
– And the wind was siller lauchin i the sun's great gowden face!
But bluid-reid was the spate that raired rambaleuch throu my hert
And dirled intil my finger-tips like needles laced wi fire.

 Gin she wad come! The time is short eneuch.
Swan, my Swan, spreid your white wings and bear
My fair Iseult acrost the spase! But mak despatch.
 Morgana's an impatient fey.

I coud hae taen her tae. She wad hae come wi me
 Til the warld's end.
Lord Christ, what's aa the chivalrous laws o courtesie
 Til twa herts reift apert for aye?
Twa herts as sacrifice til an auld lyart's honour!
 Honour! Vanitie, nae mair.
The follie, follie o't! Knichtlie troth . . .!
 And this the fell fairin.

Och, I wad liefer be a schawaldour, kennan nocht o this,
And deean blythe wi his ain clartie maistress by his side
As be thirlit til sic chivalrie, casquit and plumed,
 Til wanhowp, dule,
And, i the end, a bier unsainit wi a leman's greit . . .
 Syne sail owre the endmaist seas
Ayont the sunset til the last lang hame o Avalon
Wi a luve yet in my breist like a stanchless chaudron o desire –
– Never nae mair to find
 Rest and hert's easement,
 – Iseult! Iseult, haste ye! O, my fair!

XXIII

THE time is come, my luve,
My luve, whan I maun gae –
The sevin-pinioned bird is gyran
Intil the muir o winds;
Aneth the hills the gigants turn
In their ayebydan dwaum –
Finn under Nevis, the great King
Under Arthur's Seat, True Tammas
Neth the Eildons steers again;
As the sand rins i the gless, aince mair
Tannhäuser, wersh and wan as sin,
As I, deperts frae Horselberg,
Lane and weirdless; nou aince mair
Ulysses bids his Calypso fareweill . . .
Fareweill!

Defeatit by his ain back-slitherin,
Efter lang strachle wi the serpent slee,
Lea him at least outgang wi mockerie,
The Makar macironical!
A sang on his perjurit lips
And naething i the pouch
– Or i the hert, for that!
Music, maestro!

Bring on the Dancing Girls!
Vauntie i the muslins o Cos,
Wreathit wi hibiscus and bearan
Amphoræ o the richt Falernian!
– O let there be nae girnin at the Bar!
Chi ha vissuto per amore per amore si morì.

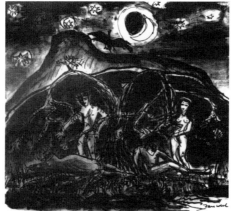

G oddess, hae I wranged ye?
 Hae my libatiouns been deficient?
Did I negleck some peerie but maist needfu
 Detail o the ritual?
Aiblins hae I been ower sanguine i the maitter
 O' the deificatioun o my beluvit?
 For Goddess, I dwyne,
 Wantan a sicht o her.
The door was steekit, neither was there answer
 Til my urgent summons,
 There was nae licht i the house,
 Tuim it was, fremmit and desertit.
Dowilie I turnit back the road I'd come . . .
And syne sat doun and made this nobil leid
 O' the spulyies o luve.

Gin my luve eer suld see it, Cynthia,
And suld she comprehend her bard,
 Her hert, as she did aince,
 (Albeid I end thus in mockerie
 In sheer sel-defence

Agin the jalous gods' decreets)
. . . Afore, 'wan wi luve's sufferance',
I turn my face until the waa,
Gar my white lass in memorie
Of our great days
Greit ae bricht tear for me, let faa
Ae tear alane . . . and it sall be
For me an ocean o the fairest wine
To slocken aye my drouth
For aa the lang eternities I'm due in hell
Mang ither bonnie victims
O' a daithless luve!

And sae fareweill!
Til you I kiss my hand, black Artemis,
Nae wreathes required –
Theres be ample roses on my road.
Aphrodite, Brigit!
Our immortalitie is in sauf keep.
Guidnicht, leddies!

Syne the hill opened
And the licht o the sun beglamert
The een like the leam o virgin snaw,
And the derkenin and the dawin
Were the sevinth year.

A lustrum endit.

Bards hae sung o lesser luves than I o thee,
Oh my great follie and my granderie.

Quod S. G. S., *Makar*, Embro Toun, Dec.1946 - Feb. 1947.

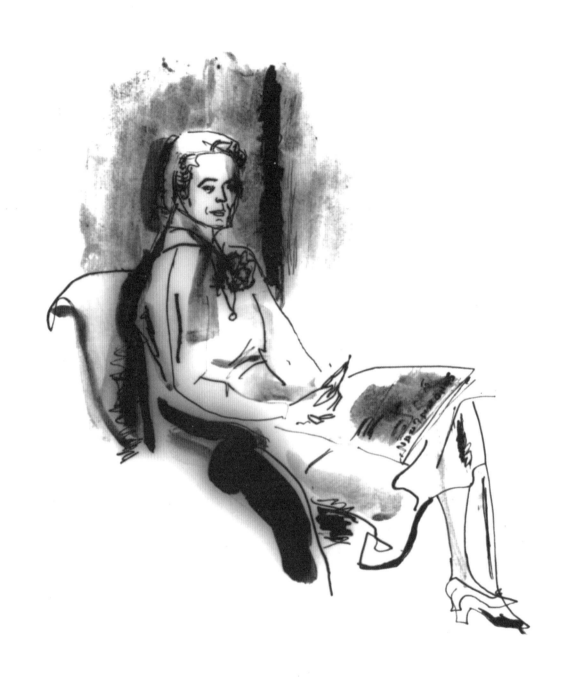

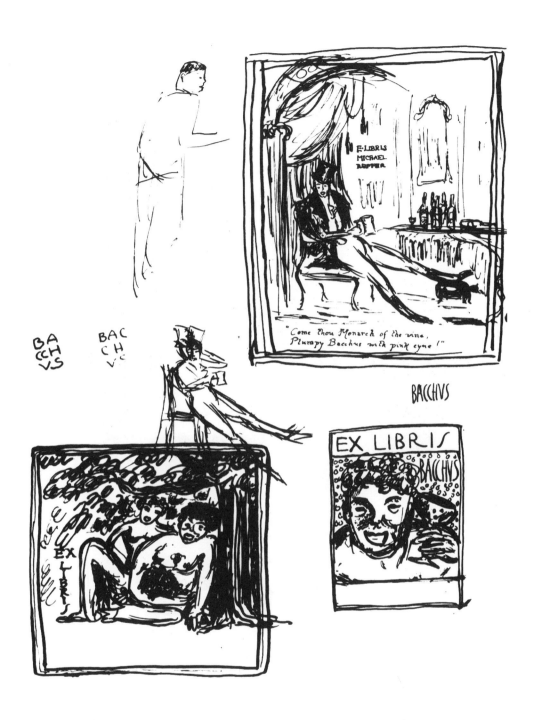

BA
CCH
VS

BAC
CH
VC

E·LIBRIS
MICHAEL
ARFFER.

"Come thou Monarch of the vine,
Plumpy Bacchus with pink eyne !"

BACCHVS

EX LIBRIS
BACCHVS

EX
LIBRIS

70

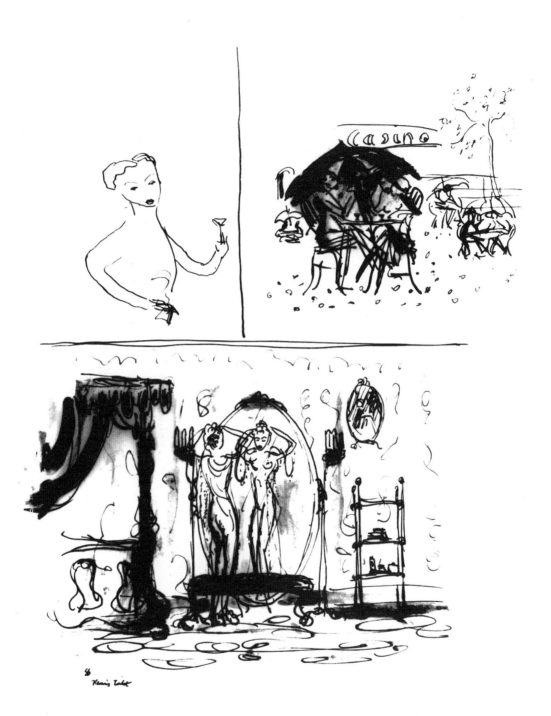

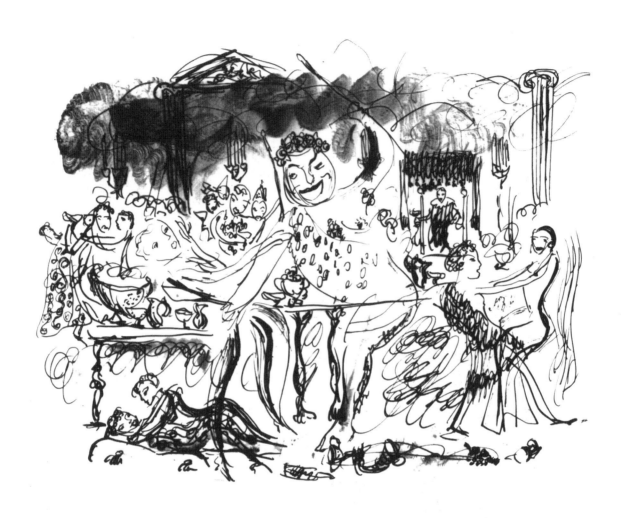

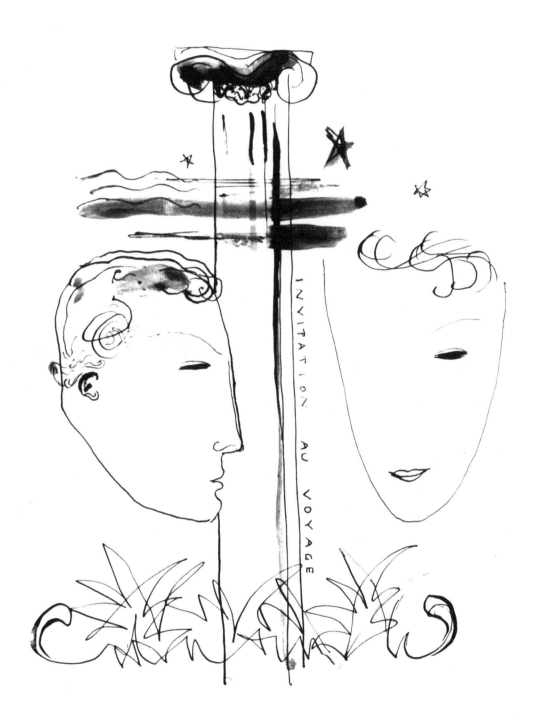

INVITATION AU VOYAGE

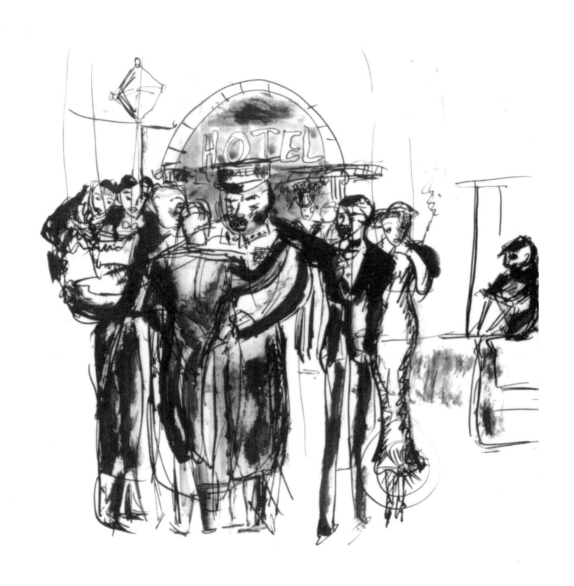

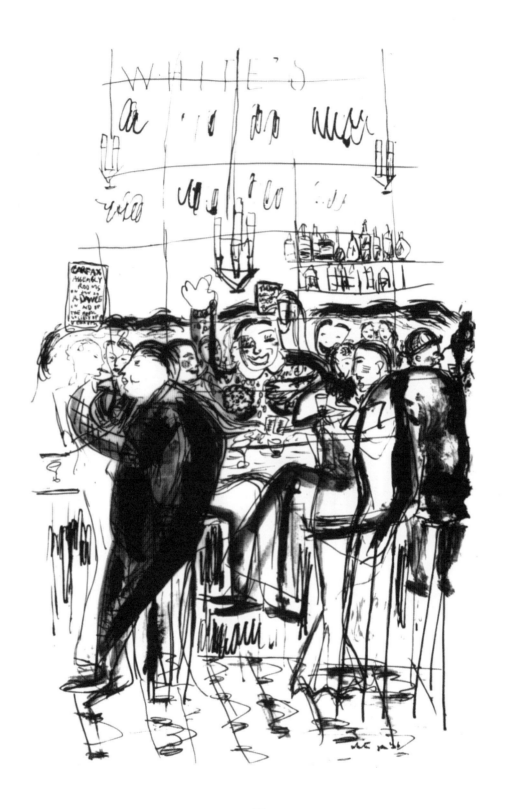

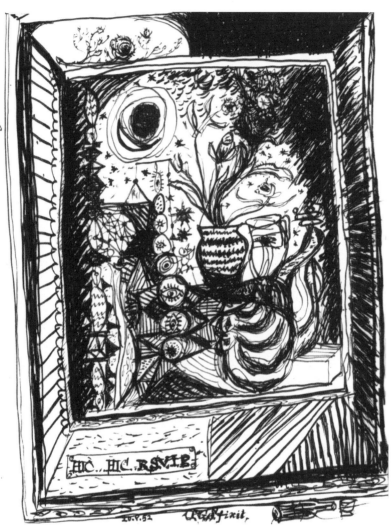

"So late into the night" 18

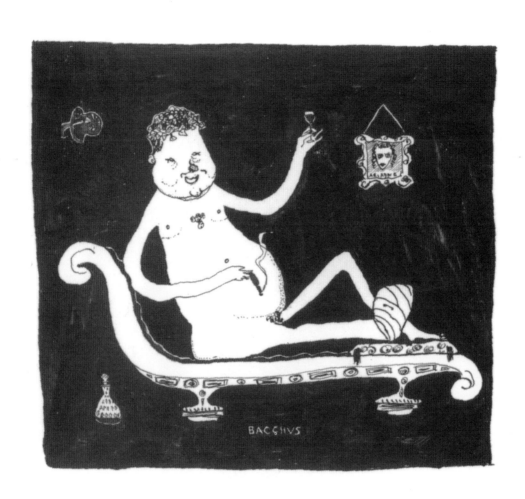

BACCHVS

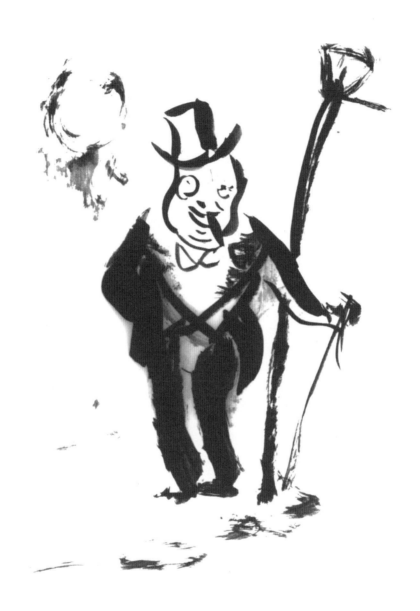

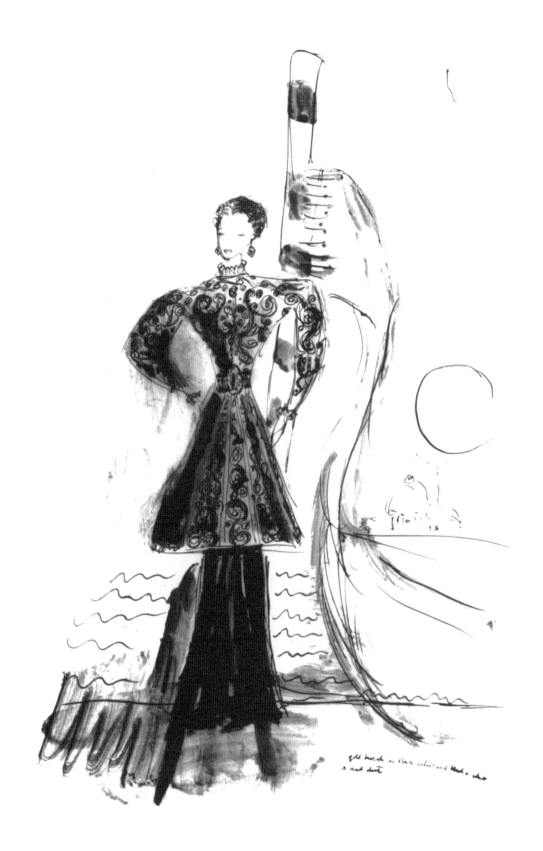

gold brocade on black velvet and black & white
& red skirt

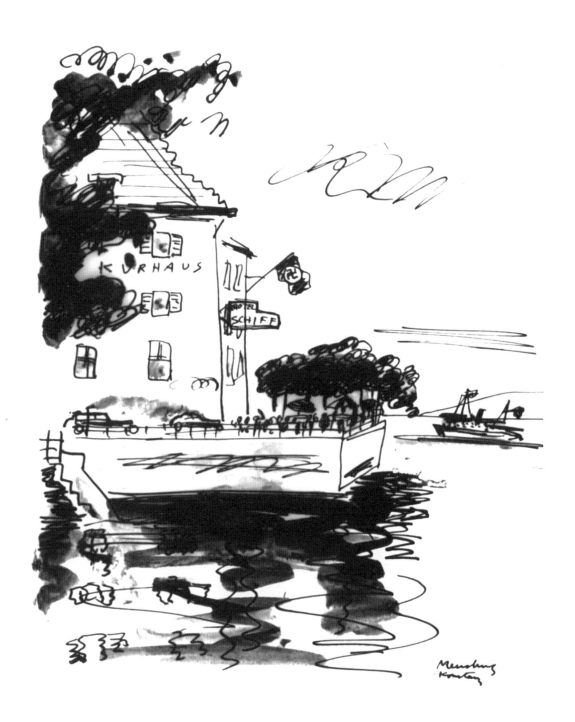

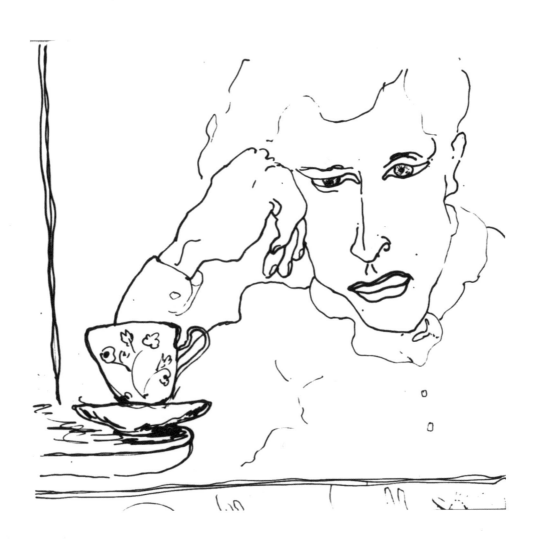

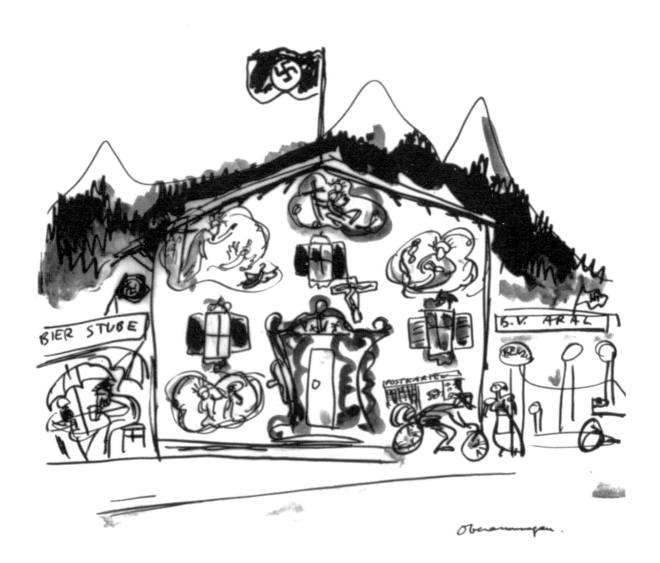

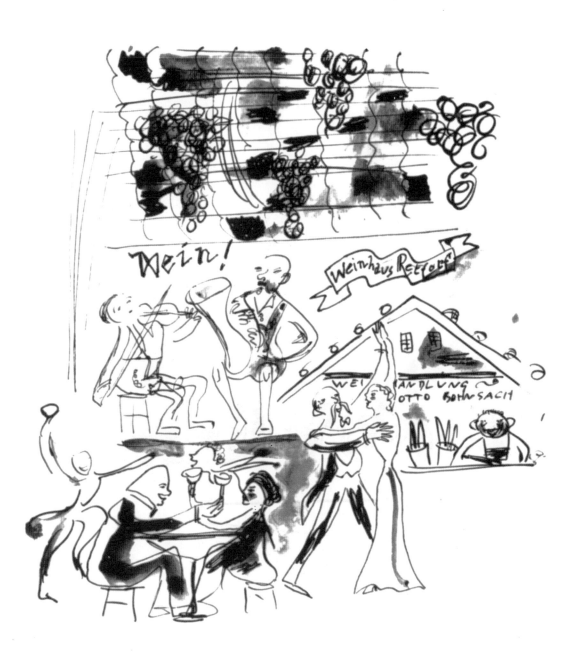

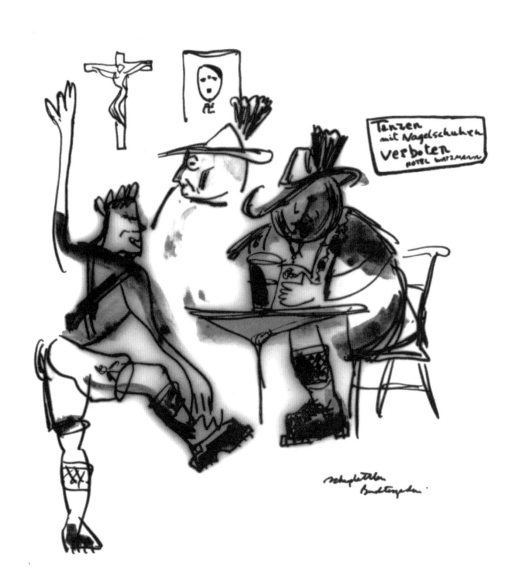

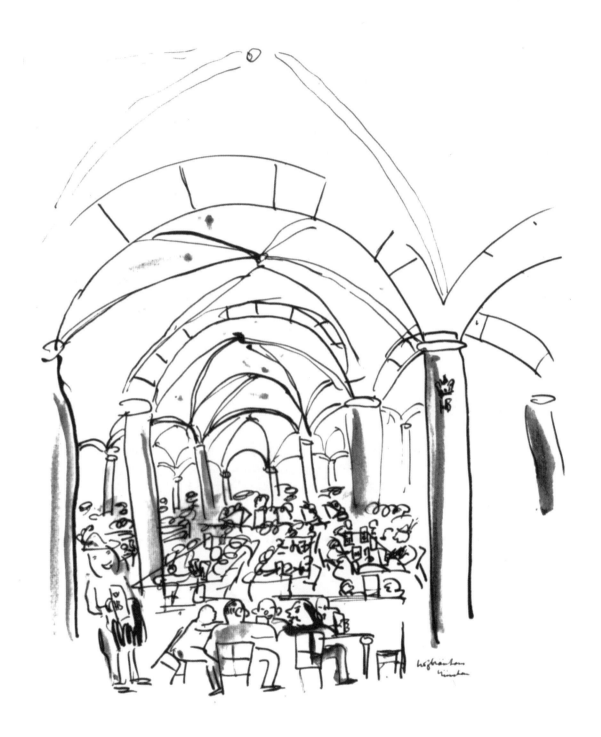

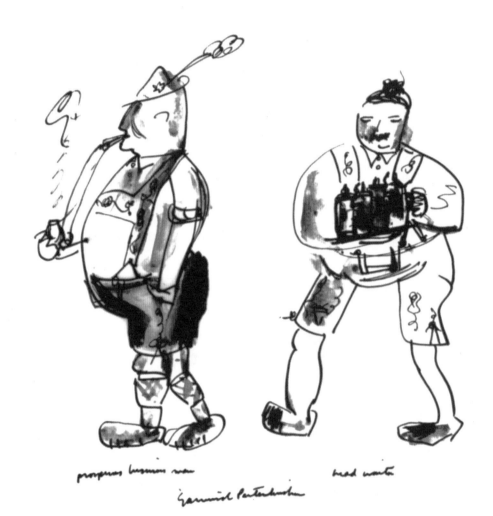

prosperous business man head waiter

Garmisch Partenkirchen

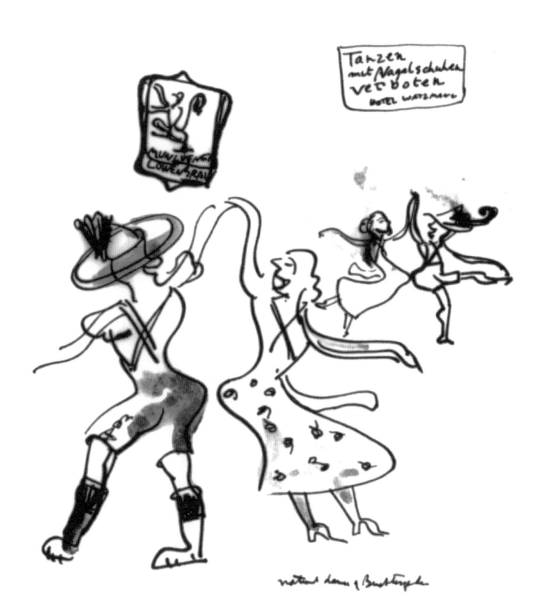

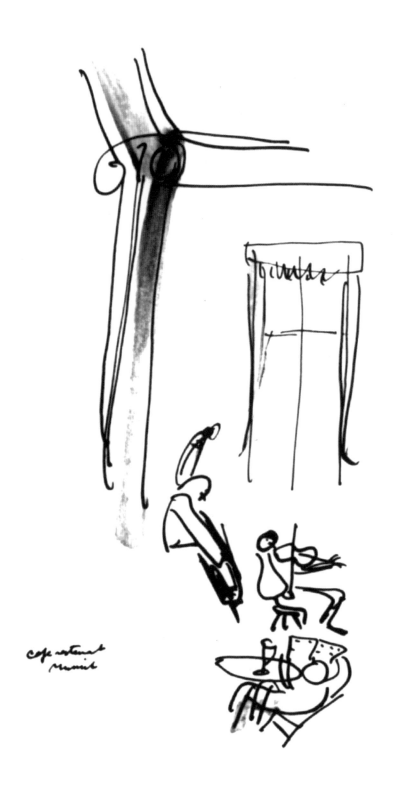

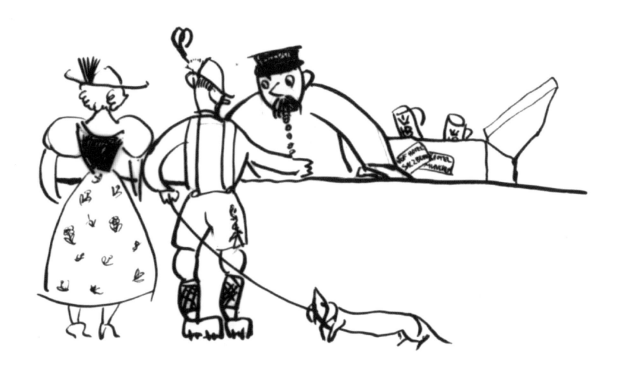

MY GOOD MAN , I TELL YOU WE
<u>DIDN'T</u> BUY ANYTHING.

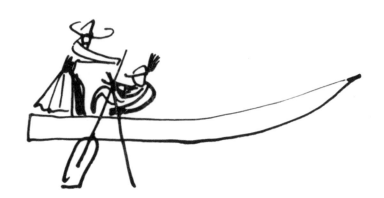

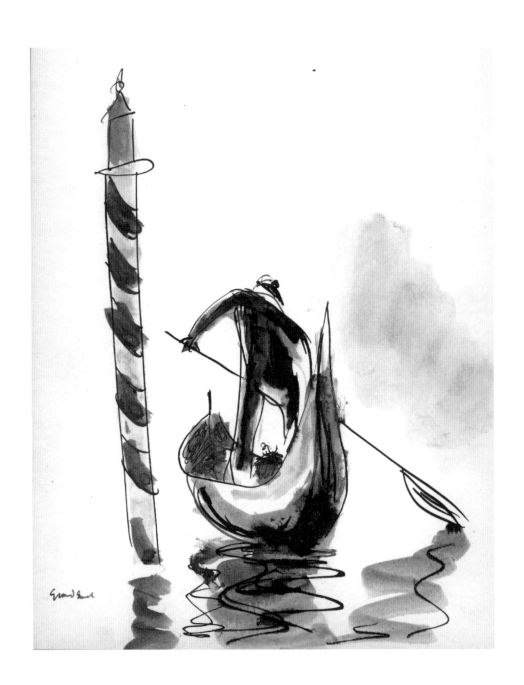

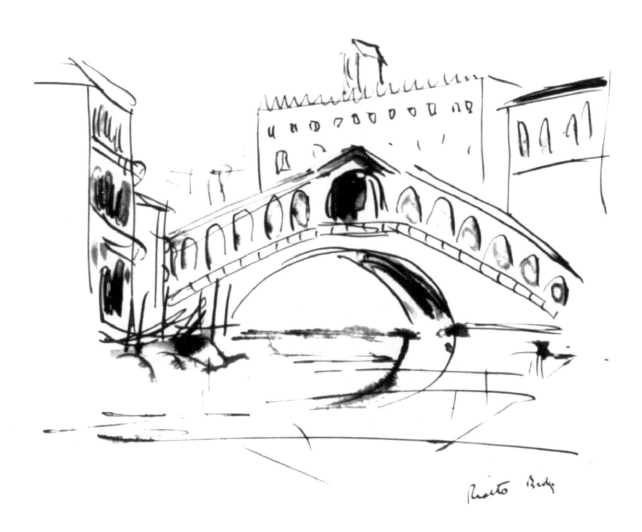

Rialto Bridge

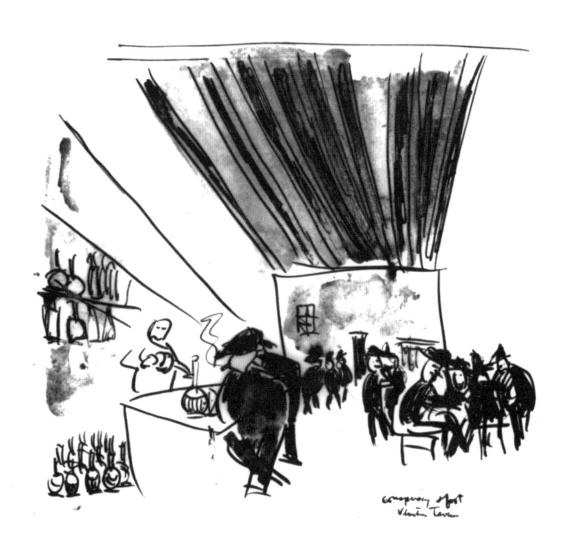

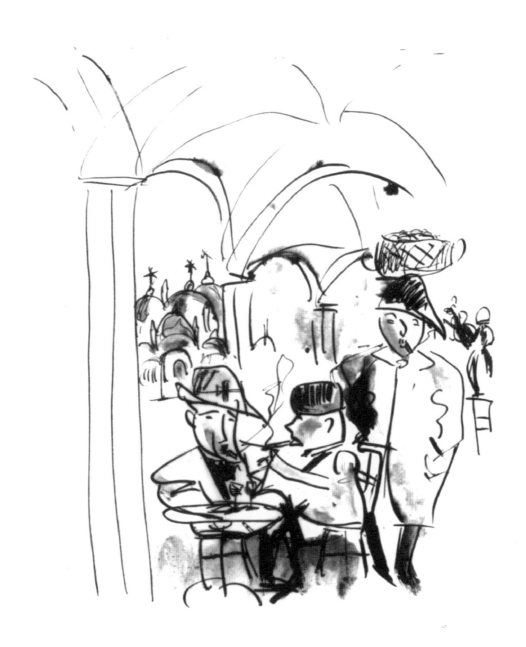

Trieste Florian's Venezia
Firenze

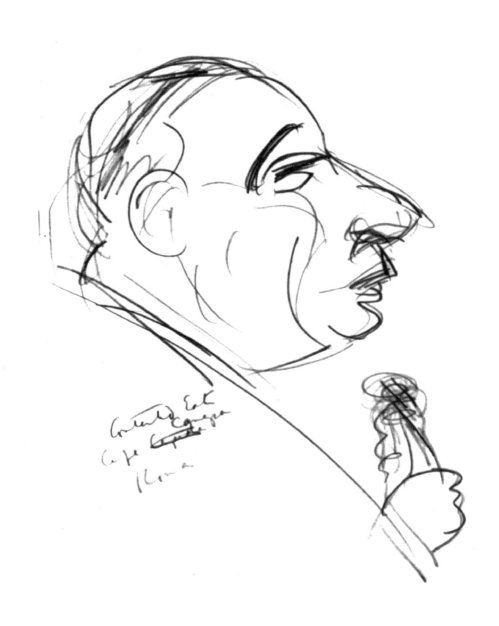

94

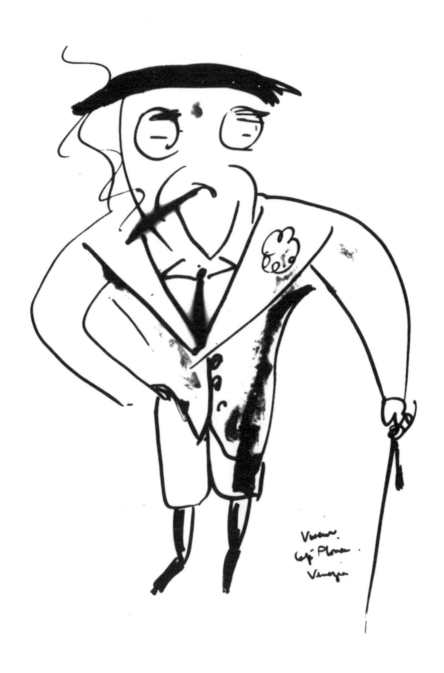

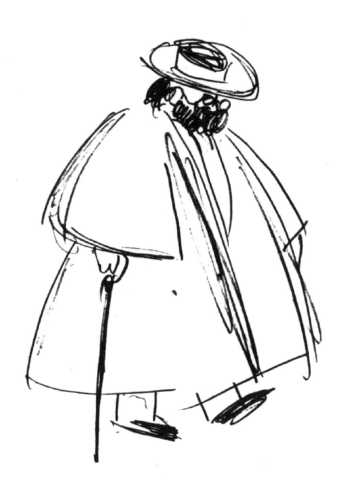

Prophet? Politian? Poet? or perhaps Panjandrum?

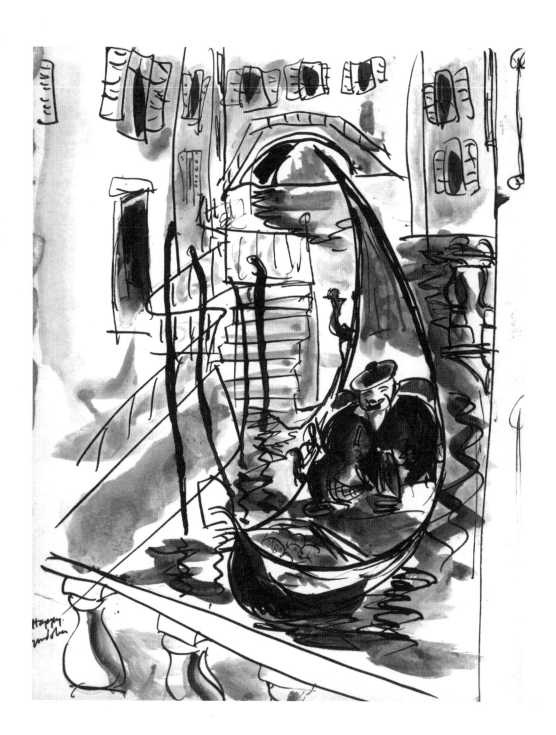

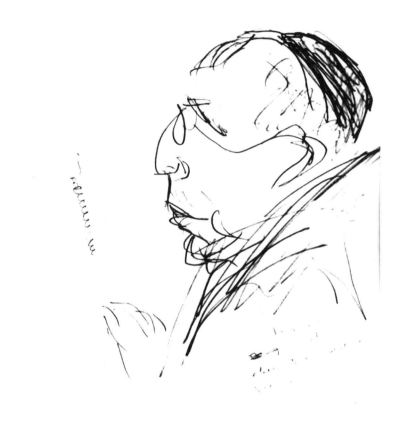

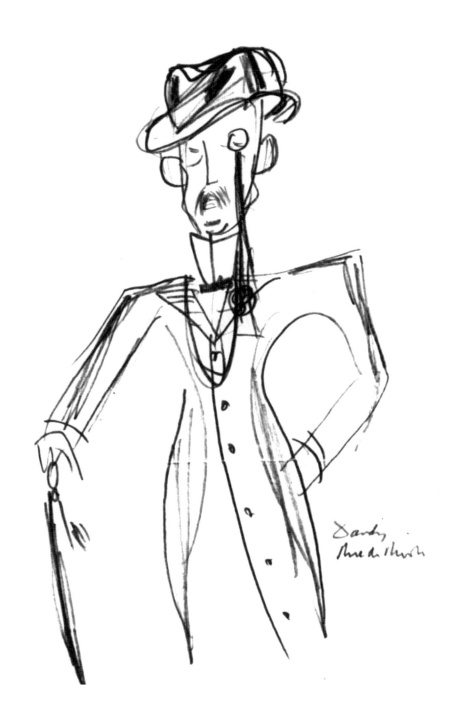

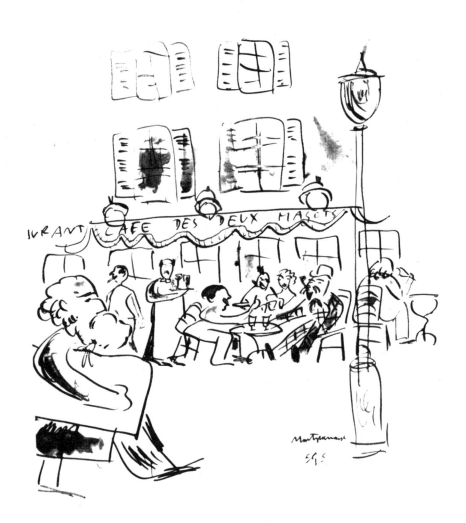

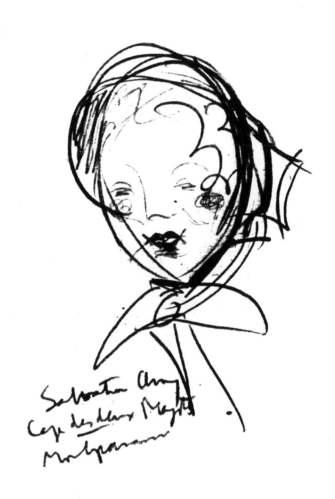

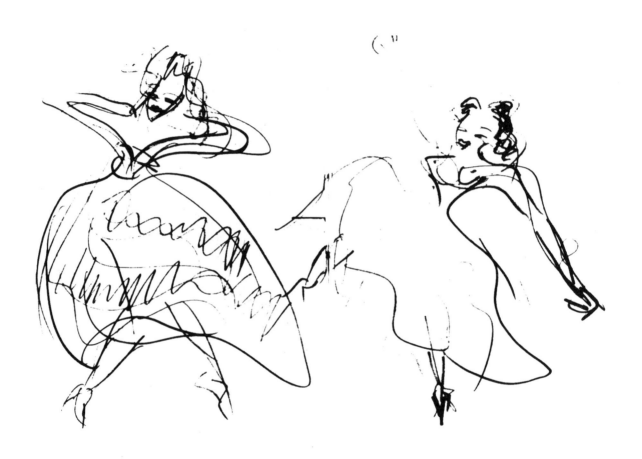

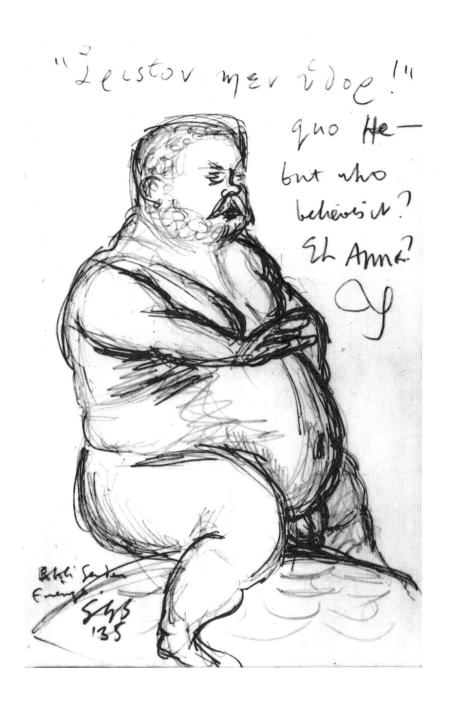

"Lecstov mer údoe!"
quo He—
but who
believes it?
Eh Anna?

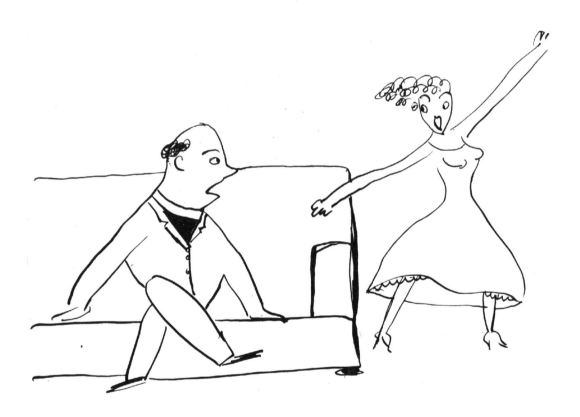

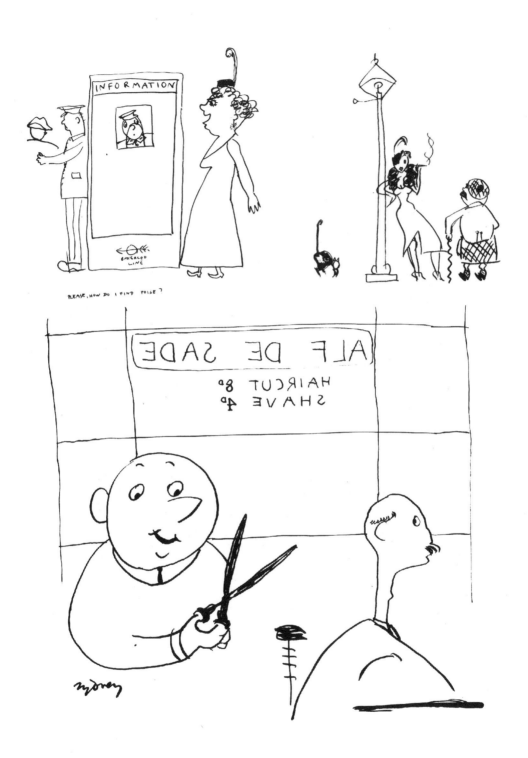

PLEASE, HOW DO I FIND POISE?

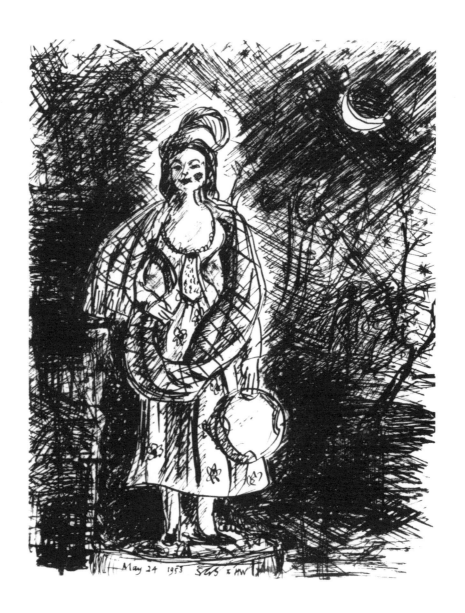

May 24 1953 SWS & MW

Largo

Ae boat anerlie nou
Fishes frae this shore
Ae black drifter lane
Riggs the crammasie daw,
Aince was a fleet, and nou
Ae boat alane gaes out.

War ir Peace, the trawler win
An the youth turns awa
Bricht wi baubles nou
An thirled tae factory or store;
Their faithers fished their ain,
Unmaistered; – ane remains.

And never the clock rins back,
The free days are owre;
The warld shrinks, we luik
Mair t'our maisters ilka hour –
Whan yon lane boat I see
Daith an rebellion blind ma ee!

K
Dec 50

1950
Kitty Smith 2 NOVEMBER

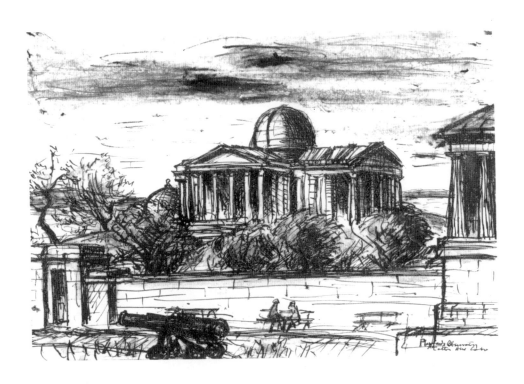

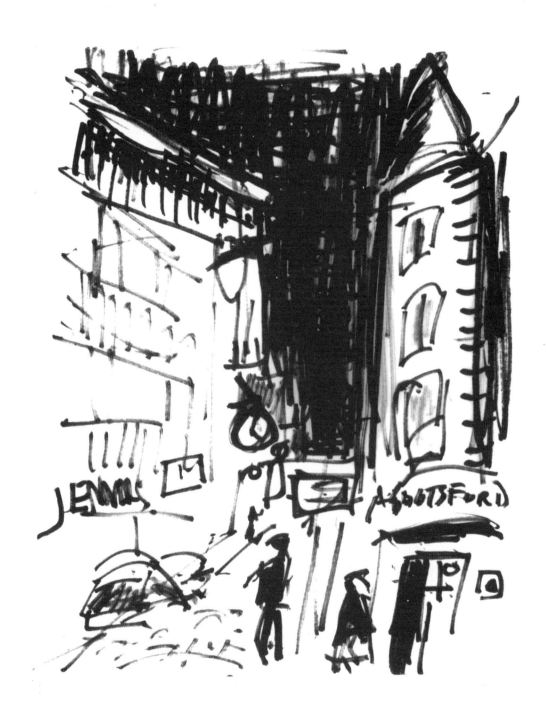

JENNERS ABBOTSFORD

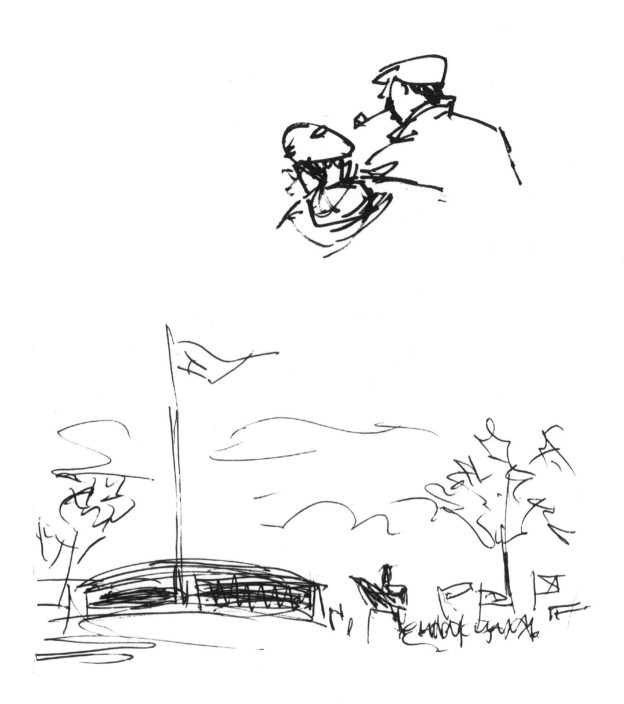

111

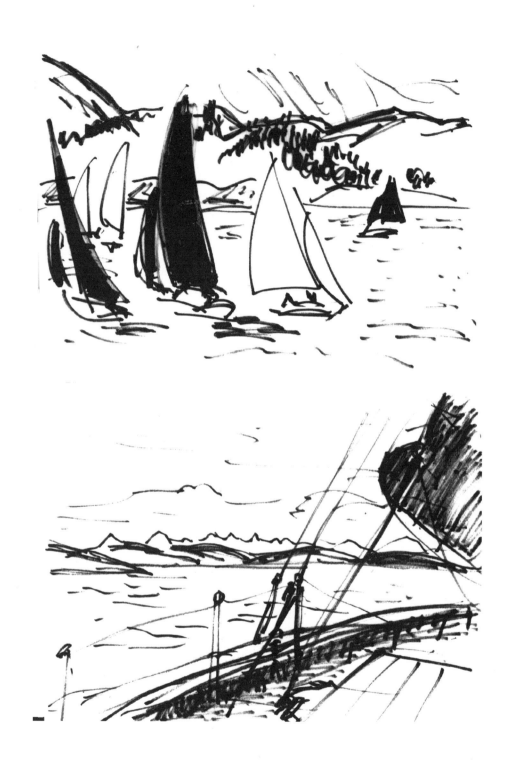

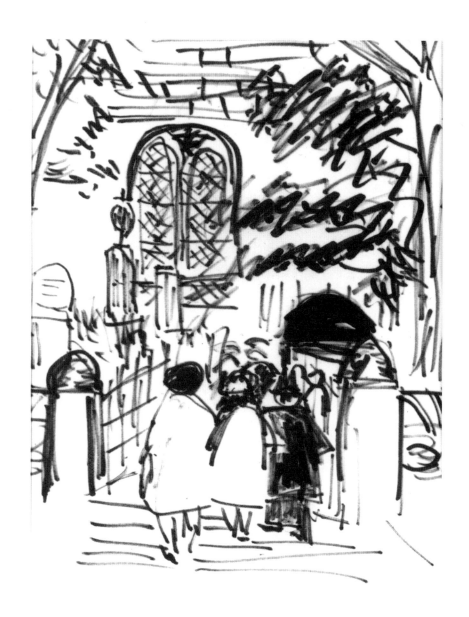

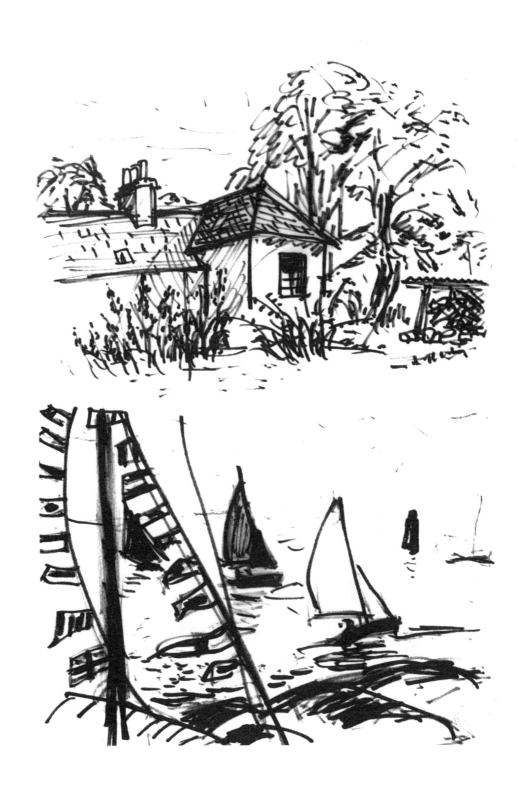

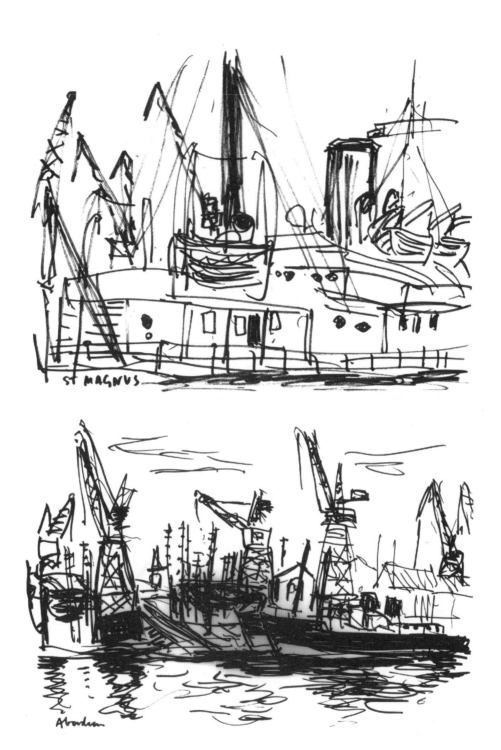

ST MAGNUS

Aberdeen

115

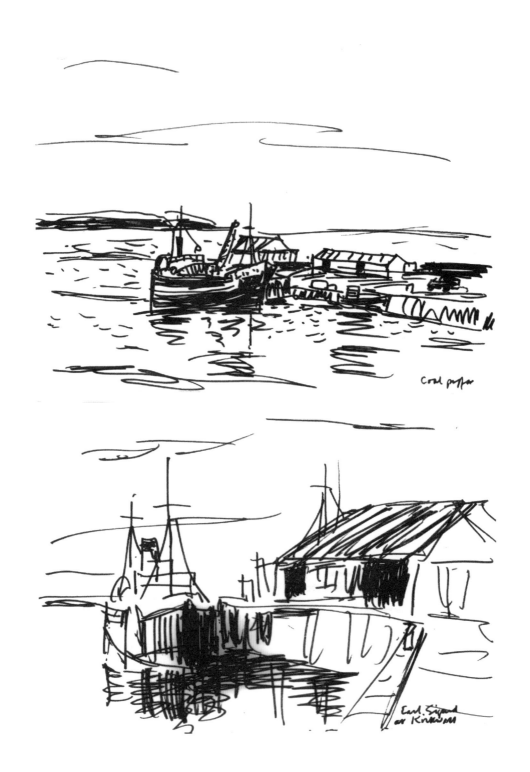

Coal puffer

Earl Sigurd
at Kirkwall

116

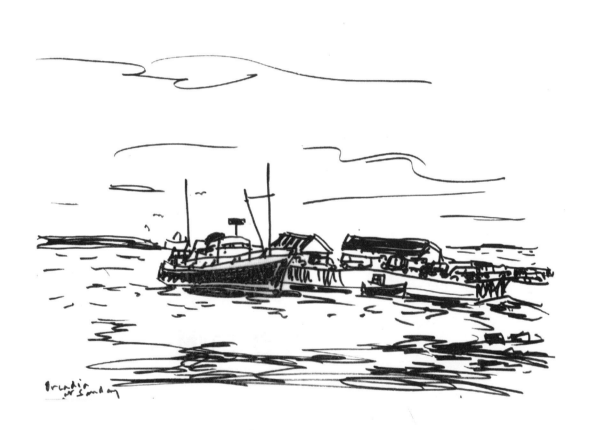

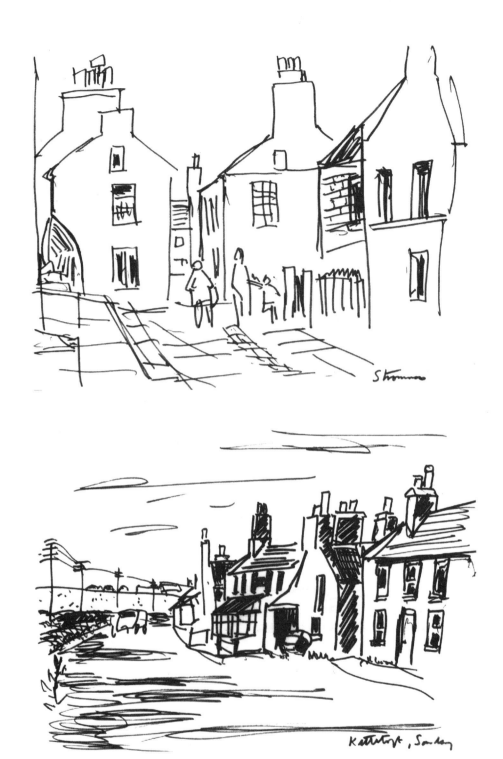

118

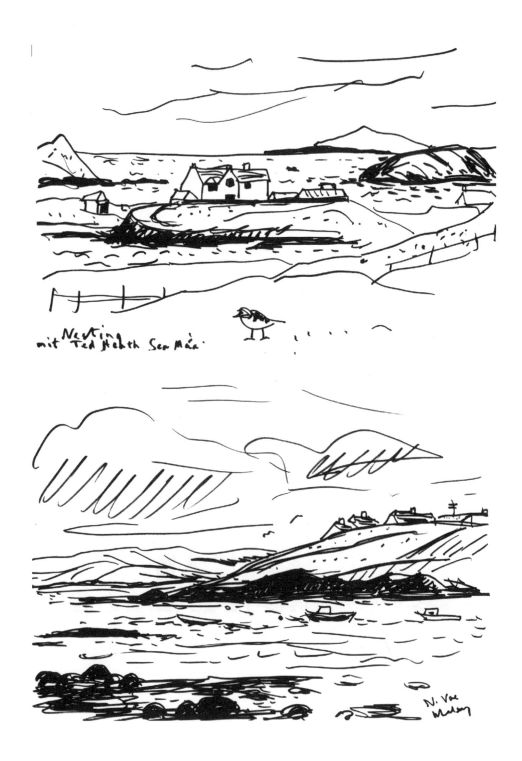

Nesting
mit Ted Heath Sea Māa.

N. Vae
Mulay

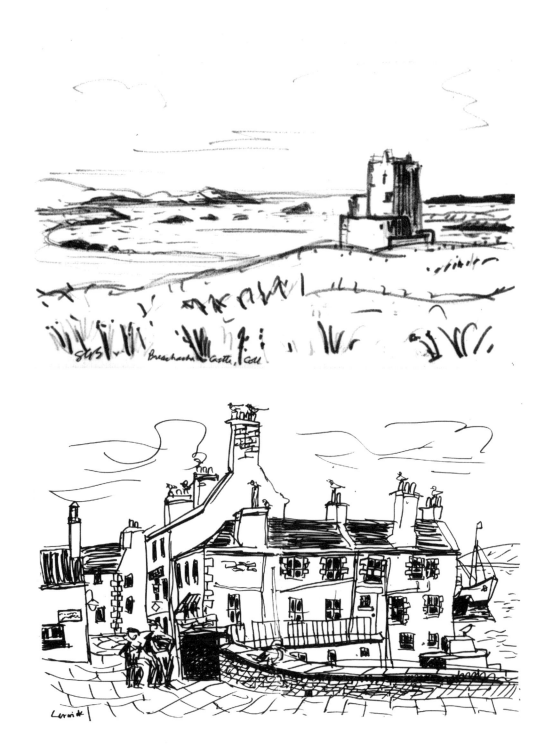

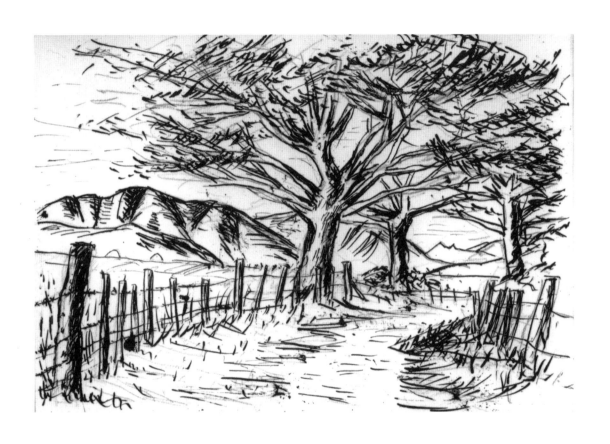

The Reid Reid Rose

It is wi luve
The thick blind dreeps
It is wi luve
The een owreshing wi sleep
It is my hert there skaithit
Wi hers — and deep
The twafauld spate
Thegither grows
Blind-choked i the
teemen hert
O' the wearie burnan
rose.

HW
from
SGS
June 26
1952

It is wi luve
The thick blind dreeps
It is wi luve
The een owreshing wi sleep
It is my hert there skaithit
Wi hers — and deep
The twafauld spate
Thegither grows
Blind-choked i the teemen hert
O' the wearie burnan rose.

122

LIST OF ILLUSTRATIONS

Cover
Page 45
Drawing. Elegy VIII *Under the Eildon Tree*, 'Newhyne', 1947.
Pen 185 x 200 NLS Acc 10211/11.

End Papers Front.
Verbal doodles probably experimenting with a new pen.
Ink 230 x 355 NLS Acc 10211/7.

Page 1 Half Title
Signature E Libris Sydney Goodsir Smith Embro Toun '46 with thistle. Pencil 50 x 100.

Page 3 Title Page
Boat with sail, from 'Newhyne', *Under the Eildon Tree* 1946. Extract from original pen and ink.
180 x 200 NLS Acc 10211/11.

Page 5 Frontispiece
Boat, a ketch West Coast of Scotland.
Felt pen 95 x 160 NLS Acc 10211/6.

Page 7 Contents
Heads from 'Newhyne', *Under the Eildon Tree* 1946. Extract from original pen and ink.
180 x 200 NLS Acc 10211/11.

Page 8 Acknowledgements
Dedication
Thistle from inside cover of notebook.
Felt pen 50 x 40 NLS Acc 10211/6.

Page 9
Portrait. Photograph of Sydney Goodsir Smith at West Bow, Edinburgh.
Photographer unknown.

Page 15
Portrait. Sydney Goodsir Smith by Denis Peploe c.1936.
Pencil 220 x 165. Hazel Goodsir Smith.

Page 16
Sydney on the Rodney, a boat owned by the late Torquil Nicolson.
Photograph by Hazel Goodsir Smith.

Page 17
Sydney with 'millionaire's hat', working.
Photograph by Hazel Goodsir Smith.

Page 18
Group in garden at Plockton Hotel, centre back Murdo Mackenzie (Buachan) who kept bar at Plockton Hotel. Sitting Isobel Nicolson called 'Mrs. Boat' by Sydney and Torquil Nicolson called 'Boat'. Reclining Sydney and Denis Peploe called 'Paint' by Sydney. Centre front Cluny Dog Mk. 1. Photograph by Hazel Goodsir Smith.

Page 19
Sydney with pint of beer in garden, Plockton Hotel.
Photograph by Hazel Goodsir Smith.

Page 20
Drawing. Men in Club c. 1937.
Pen and Ink 80 x 150 NLS Acc 10211/10.

Page 22
Photograph. Sydney with sister Bet as nurse taking his temperature c. 1924.

Page 24
Postcard from 'The Paperback' bookshop, Edinburgh. Jim Haynes, unknownlady, the late Tom Scott, poet, and Sydney c. 1960.

Page 25
Drawing. Badluarach. Cottage Sydney and Hazel considered buying on Little Loch Broom Sutherland c. 1970. Felt pen 180 x 235 NLS Acc 10211/9.

Page 62
Drawing. Initial letter S for Elegy XX (XIX on drawing) *Under the Eildon Tree*, 'Tristram', 1947.
Pen and wash 235 x 220 NLS Acc 10211/11.

Page 65
Drawing. Initial word 'THE' for Elegy XXIII *Under the Eildon Tree*, 'The Time is Come', 1947.
Pen and wash 125 x 130 NLS Acc 10211/11.

Page 66
Drawing. Initial letter G for Elegy XXIV *Under the Eildon Tree*, 'Fareweill', 1947.
Pen and wash 240 x 220 NLS Acc 10211/11.

Page 68
Drawing. Lady holding glasses, newspaper on her knee, possibly Sydney's mother c. 1937.
Pen and wash 240 x 195 NLS Acc 10211/12.

Page 69
Drawings. 3 bookplates and lettering c. 1937.
Pen 260 x 195 NLS Acc 10211/12.

Page 70
Drawing. Girl c. 1937.
Pen and wash 270 x 205 NLS Acc 10211/11.

Page 71
Drawings. 3 sketches of female figures (1 with cocktail glass, 2 at Café Casino, 3 in bedroom at large cheval-glass. Initialled SS Fleur's toilet) c. 1937.
Pen and wash 230 x 200 NLS Acc 10211/12.

Page 72
Drawing. Bacchanalia c. 1937. Initialled SS.
Pen and wash 160 x 190 NLS Acc 10211/12.

Page 73
Drawing. 'Invitation au Voyage' male and female heads with classical column, stars and vegetation, 1937.
Pen and wash 215 x 160 NLS Acc 10211/12.

Page 74
Drawing. Hotel entrance. Commissionaire and cocktail set c. 1937.
Pen and wash 205 x 190 NLS Acc 10211/12.

Page 75
Drawing. Cocktail bar c. 1937.
Pen and wash 350 x 230 NLS Acc 10211/12.

Page 76
Drawing. 'So late into the night' 'HIC.HIC.RSVIP 20.V.52 Signature SGS fixit?
Pen 230 x 180 NLS Acc 10211/7.

Page 77
Drawing. 'BACCVS' Picture named 'ARIADNE' c. 1937.
Pen and wash 185 x 170 NLS Acc 10211/12.

Page 78
Drawing. Tipsy Dandy c. 1937.
Brush 260 x 170 NLS Acc 10211/12.

Page 79
Drawing. Fashion Drawing showing female figure in Venice, 'Gold brocade on black velvet with black v skirt and red darts' c. 1937.
Pen and wash 295 x 205 NLS Acc 10211/12.

Page 80
Drawing. Hotel Schiff with Nazi Flag Meersburg, Konstanz, 1936.
Pen and wash 215 x 180 NLS Acc 10211/8.

Page 81
Drawing. Head pensive with tea cup, 1937.
Pen 190 x 225 NLS Acc 10211/11.

Page 82
Drawing. 'Oberammergau', 1936.
Pen and wash 150 x 175 NLS Acc 10211/8.

Page 83
Drawing. 'Wein', musicians, dancers and drinkers, 1936.
Pen and wash 185 x 170 NLS Acc 10211/8.

Page 84
Drawing. 'Schuplattlen Berchtesgaden'. Crucifix and Hitler on the wall, 1936.
Pen and wash 155 x 155 NLS Acc 10211/8.

Page 85
Drawing. 'Hofbräuhaus München', 1936.
Pen and wash 220 x 175 NLS Acc 10211/8.

Page 86
Drawing. 'Garmisch-Partenkirchen', 'prosperous business man' and 'head waiter', 1936.
Pen and wash 150 x 140 NLS Acc 10211/8.

Page 87
Drawing. 'National dance of Berchtesgaden'.
Notices on the wall, 1936.
Pen and wash 145 x 125 NLS Acc 10211/8.

Page 88
Drawing. 'Café Restaurant Munich', 1936.
Pen and wash 170 x 75 NLS Acc 10211/8.

Page 89
Drawing. 'My Good Man, I tell you we didn't
buy anything.', 1936.
Pen 135 x 165 NLS Acc 10211/1.

Page 89
Drawing. Couple on boat, Bavaria, 1936.
Pen 40 x 75 NLS Acc 10211/8.

Page 90
Drawing. Grand Canal, Venice, 1937. Pen and
wash 222 x 172. Ewan MacCaig.

Page 91
Drawing. 'Rialto Bridge', Venice, 1937.
Pen and wash 125 x 160 NLS Acc 10211/8.

Page 92
Drawing. 'Conspiracy afoot Venetian Tavern',
1937.
Pen and wash 150 x 150 NLS Acc 10211/8.

Page 93
Drawing. Fascisti Florian's Venezia, 1937.
Pen and wash 220 x 180 NLS Acc 10211/8.

Page 94
Drawing. 'Contented Eats Café Canepa Roma',
1937.
Pen 140 x 110 NLS Acc 10211/2.

Page 95
Drawing 'Viveur Café Florian Venezia', 1937.
Pen and wash 200 x 125 NLS Acc 10211/8.

Page 96
Drawing. 'Prophet? Politician? Poet or
Panjandrum'
c. 1937. Pen 135 x 105 NLS Acc 10211/8.

Page 97
Drawing. 'Happy Gondolier', 1937. Pen and
wash 222 x 172. Ewan MacCaig.

Page 98
Drawing. 'Kind Monk Catacomb or
S.Sebastian Via Appia Roma', 1937.
Pen 125x110 NLS Acc 10211/2.

Page 98
Drawing. Gondolas,1937.
Pen 55 x 115 NLS Acc 102 11/2.

Page 99
Drawing. 'Dandy Rue di Rivoli' c. 1937.
Pencil 155 x 95 NLS Acc 10211/2.

Page 100
Drawing. Café des Deux Magots, 1937.
Ink 230 x 165 Hazel Goodsir Smith.

Page 101
Drawing. 'Salvation Army Café des Deux
Magots, Montparnasse' (sic), 1937.
Pencil 140 x 100 NLS Acc 10211/2.

Page 102
Drawing. Female dancers Bal Tabarin,
Paris c. 1937.
Pencil 170 x 220 NLS Acc 10211/2.

Page 103
Drawing. Figure in Bobili Garden
Firenze c. 1937.
Pencil 180 x 120. Professor Anna MacLeod.

Page 104
Drawing. Hand appearing from manhole.
Pen 60 x 100 NLS Acc 10211/10.

Page 104
Drawing. Minister and shocked female.
Pen 180 x 255 NLS Acc 10211/10.

Page 105
Drawing. 'Please how do I find poise?'
Pen 210 x 200 NLS Acc 10211/1.

Page 105
Drawing. Scotsman facing prostitute, with cat.
Pen 165 x 165 NLS Acc 10211/10.

Page 105
Drawing. 'ALF DE SADE' signed Sydney.
Pen 180 x 190 NLS Acc 10211/10.

Page 106
Drawing. Staffordshire figure, 1953.
Pencil 230 x 165. Hazel Goodsir Smith.

not love from alias or Smith be Good !